759.4 DEG

Keith Roberts

DEGAS

PHAIDON

The publishers are grateful to the following for the loan of photographs: Sotheby & Co., London (Plate 19); Christies, London (Plate 41).

Phaidon Press Limited, Littlegate House, St Ebbe's Street, Oxford
Published in the United States of America by E. P. Dutton & Co., Inc.

First published 1976

© *1976 Elsevier Publishing Projects SA, Lausanne/Smeets Illustrated Projects, Weert*
Text © *1976 by Keith Roberts*

ISBN 0 7148 1738 4
Library of Congress Catalog Card Number: 76-387

Printed in The Netherlands

DEGAS

If the Word Association Test were applied to Degas, what might be the results? For a great many people: images of the ballet, of race-horses and of women washing themselves. The more knowledgeable might add: an Impressionist, a wit, a man who went slowly blind. The expert could extend the list further: a superb copyist of the Old Masters, an exquisite draughtsman, an exceptionally intelligent artist whose attitude towards Impressionism was equivocal.

Degas was, and has remained, a somewhat paradoxical figure. After Seurat he is the least well known individual personality among the major Impressionists and Post-Impressionists. Set beside the hedonistic, easy-going Renoir, the flamboyantly arrogant Gauguin or the self-destructively intense and pathetic Van Gogh, Degas seems an aloof and very private man, self-absorbed, inclined to cynicism, his feelings concealed behind a battery of often scornful wit, and with more than a hint of the prematurely aged response to life sometimes found in highly intelligent people who have few illusions and little faith in their fellow men. Like Flaubert, the creator of that pioneering masterpiece of Realism, *Madame Bovary*, and like Leonardo da Vinci, the Renaissance artist with whom he had most in common and whose works he copied, Degas was a pessimist. His art is without the simple joyous and affirmative qualities that one associates with the paintings of Renoir, Monet, Pissarro, Sisley, Gauguin and Van Gogh. Reticence, control and a highly calculated kind of objectivity lie at the heart of Degas's vision. He was not what is usually thought of as a lovable man; and his art has its distinctly chilly side. But the response to visual facts was so fastidious and so acute, the mastery of design so vigorous and so sure, and the feeling for art, for what a work of art is about, so intense that Degas's oeuvre is among the most deeply satisfying artistic achievements of the nineteenth century, an age astonishingly rich in great painting.

He was born Edgar De Gas (later contracted to Degas) in Paris on 19 July 1834, the eldest of five children. Madame De Gas belonged to a French family that had settled in America. Degas worshipped his mother, and her death in 1847, when he was thirteen, was a tragedy he never forgot. His father was a banker of cultivated taste, devoted to music and the theatre, and he encouraged his son's artistic inclinations. From 1845 to 1852, Degas studied at the Lycée Louis-le-Grand, where he was given a good classical education; his best subjects were Latin, Greek, History and Recitation – an early symptom of his life-long passion for the theatre and its calculated artifice.

Degas then enrolled in Law School, but he did not stay long. He was too anxious to be a painter. Already, in 1852, he had been allowed to transform a room in the family home in the Rue Mondivi into a studio; and in the following year he began to work under Félix Joseph Barrias. He spent a good deal of his time copying the Old Masters in the Louvre and studying the prints of Dürer, Mantegna, Goya and Rembrandt. In 1854, Degas went to study with Louis Lamothe, an ardent disciple of Ingres (1780–1867), the great upholder of the classical tradition of painting going back to the Italian High Renaissance, a tradition for which Degas, too, was always to retain the greatest respect.

In 1855, Degas began to study at the Ecole des Beaux-Arts; but he found the

course unprofitable and the régime too restricting. To study the classical tradition on home ground seemed more sensible. With hospitable relatives in Florence and Naples, he was able to make long and regular trips to Italy between 1854 and 1859. Degas studied hard, making copies of Italian pictures he admired and filling sketchbooks with studies, compositions and precepts. Of his Impressionist contemporaries, only Cézanne was to study and copy the Old Masters to anything like the same degree. When in Rome, Degas enjoyed the lively and stimulating company of friends and acquaintances living either in or near the French Academy.

A minor incident of the mid-1850s highlights the ambiguities of Degas's aesthetic position. Among the most admired features of the 1855 Paris World Fair was a gallery devoted to the work of Ingres, the most respected French painter of the age. At the planning stage, Ingres asked for an early *Bather* of 1808 to be included, but the owner, a friend of M. Degas senior named Edouard Valpinçon, refused to lend the picture. The young Degas was incensed that a mere owner should have rejected the plea of a great artist; and he was able to persuade M. Valpinçon to change his mind. Impressed by the student's ardour, Valpinçon took Degas to see Ingres, to whom he then related the whole story. The painter, then in his mid-70s, was touched and, when he learned that the boy wished to become a painter too, gave him a piece of advice: 'Draw lines, young man, many lines, from memory or from nature; it is in this way that you will become a good artist.'

Like the advice often meted out by the old and famous to the young and unknown, Ingres's words were sympathetic, rather vague and a shade patronizing. But Degas was never to forget them; they formed the substance of his favourite anecdote. The meeting had been all too brief but it was to play a symbolic role in his life. The plain words of Ingres came to assume the character of magic cyphers implying, as far as Degas was concerned, a whole philosophy of art, exemplified in the thirty-seven drawings and twenty paintings by Ingres that he eventually owned.

It might at first seem strange that Degas – known to everyone who has ever been inside an art gallery as the painter, par excellence, of the ballet (e.g. Plates 11, 20, 46, 47), the race-track (Plates 10, 16, 22), the theatre (Plates 13, 26) and the nude in domestic surroundings (Plates 40, 41, 48) – should have revered the sayings and work of an artist apparently so very different. Ingres was an exceptionally conservative figure, who had set his face against nineteenth-century progress, worshipped at High Renaissance shrines and lovingly borrowed ideas from the work of Raphael. Classical myths and episodes from religious and secular history were his preferred subject-matter.

A little of the mystery evaporates, however, when we recall that Degas in his youth tried to paint in the Ingres tradition. Three of these early history pictures are reproduced here: *Semiramis building Babylon* (Plate 4), *The Young Spartans* (Plates 5 and 7) and *Scenes from War in the Middle Ages* (detail, Plate 6). The first two, in which the figures are spread out across the canvas in a shallow frieze, are even composed in the Ingres manner. And like Ingres, Degas made many preparatory studies, for various parts as well as for the designs as a whole. Of these early history pictures, *The Young Spartans* (Plate 5) is the most successful. The subject is a simple one: in ancient Sparta boys and girls exercised together, and in the painting the Spartan girls have just challenged the boys to a contest.

Degas spent a good deal of time on the work, making preliminary drawings for individual figures and altering the overall design more than once. But the 'correct'

4

classical tone, lying somewhere between the slightly frigid mood of Ingres' own work and the adroit mixture of idealization and archaeology that was a sure recipe for official success as a painter in France throughout the nineteenth century, still eluded him. *The Young Spartans*, fortunately, is as little like a conventional nineteenth-century history picture as it is possible to imagine. The colour is as delicate and understated as the drawing. There are no hard lines, no rhetoric, and little or no evidence of archaeological research; instead an impression of casual everyday life, a subtle study of adolescence with its touching interplay of boldness, silliness, curiosity and shyness.

There is an earlier variant of the painting in existence, however, and it is more traditional in character. There is a Greek temple in the background and the girls have been given classical headgear and idealized profiles with straight noses. In the final version in the National Gallery (Plate 5) they have the snub noses of Parisian *jeunes filles*. What induced Degas, self-confessed admirer of Ingres and the classical tradition, to make so conspicuously informal an alteration?

The simplest answer would be to say an awareness of modern life. In April 1859 Degas had taken a studio in the Rue Madame in Paris. As well as historical subjects, he also began to paint portraits (the largest and most ambitious of all his essays in portraiture, *The Bellelli Family*, now in the Louvre, belongs to the late '50s and early '60s). In 1862, Degas met the painter Edouard Manet (1832–83), who was becoming increasingly interested in themes from modern life in preference to more traditional kinds of subject-matter. Degas also met Edmond Duranty (1833–80), a critic, novelist and friend of Manet. Duranty was a passionate believer in 'Realism', and was anxious to break down the barrier he felt existed between art and daily life. Degas was later to paint a superb portrait of him (Plate 34).

Degas soon became a familiar figure at the Café Guerbois, where many of the artists most closely associated with what became known, after 1874, as Impressionism were accustomed to meet and talk in the evenings. Degas's art began to reflect his changing views in the second half of the 1860s, when he gave up the historical genre and turned for inspiration to the racecourse (Plates 10, 16) and the theatre (Plates 11, 13). He continued to exhibit at the official Paris Salon until 1870. In the Franco-Prussian War (1870–1), Degas served in the Artillery; and it was after a severe chill contracted during this military service that his eyes first began to give him trouble.

But what exactly do we mean, and what might Degas have understood, by the phrase 'an awareness of modern life'? A number of things, related and combined: chiefly an unbiased attitude towards permissible subject-matter, so that a fascination with the small change of everyday life became strong enough to replace traditional, Old Master-ish themes as the proper diet for the creative imagination, and a growing desire to find a style, an angle of vision, in accord with the nature of the material. Degas's chief aim, throughout his career, was to make the spectator conscious, in wholly pictorial terms, of the quality of ordinary life; and at the centre of his art was a visual analysis of the human being, the human body, the way it sits, stands, walks and gestures, its grace (Plate 30), its weight (Plate 35), what it can be made to accomplish by training and discipline (Plates 15, 31), what it may be forced to do through circumstance (Plates 37 and 38). Degas wanted to capture an illusion of life without distorting it in the very process of giving it a memorable aesthetic form.

The task was not made any easier by Degas's fundamental ambivalence towards

the world in which he lived. Ingres did his best to forget that he was living in Paris in the nineteenth century. But it was precisely this fact that Degas could not forget. He may not have been pleased with modern life: 'they were dirty,' he once said of the era of Louis XIV, 'but they were distinguished; we are clean, but we are common.' Yet he came to accept it. His appetite for what was actual and real was simply too acute to remain satisfied with the trappings of the classical style. The toga, the Doric capital and the ageless legends of Antiquity might stand for sublime values and a nobler mode of being; but there was something shadowy about them, and like a ghost at cock-crow they faded in the glare of the gas jets that illuminated the streets, cafés and theatres of modern Paris.

But there are no railway trains or rolling mills in Degas's work. His attitude to contemporary life was never the arid token of a self-conscious philosophy, willing to see in every new-fangled piece of machinery the soul of the nineteenth century, but a natural and spontaneous effusion of his nerves, his sense of humour, his curiosity and his imagination. An excellent mimic, he developed an insatiable interest in behaviour, the seemingly trivial detail, the sudden need to yawn (Plate 38), scratch one's back (Plate 46) or adjust a shoe (Plate 15). Degas was a brilliant observer of ordinary life, and it was this as much as his compositional devices or his attitude towards light that marks him out as a true Impressionist, to be ranked with Monet, Pissarro and Renoir.

These, then, were the two basic poles round which Degas's mind, his temperament and his artistic personality revolved: a feeling for modern life, and a sense of artistic tradition. But far from dividing his talent into two and reducing him to creative impotence, the rival claims grew together, nourishing his abilities and clarifying his perceptions, and like the different coloured lenses in a pair of toy glasses they enabled him to see his own art and the aesthetic situation of the day with stereoscopic clarity.

In a letter to a friend, Degas regretted that he had not lived at a time when painters, unaware of women in bath tubs, had been free to paint Susanna and the Elders. At the same time he sensed that the whole temper of the nineteenth century, with its materialism and stress on scientific investigation and the objective record, was subtly destroying the delicate balance between imagination and fact on which for centuries the success of historical and Biblical painting had depended. Religious art in the tradition established by Leonardo da Vinci, Michelangelo and Raphael could never survive topographically accurate records of the Holy Land.

Degas had a sharp and witty tongue and he spared no one, least of all his friends. He did not conceal from Gustave Moreau that he had no time for his highly detailed mythological and religious fantasies: 'He wants to make us believe the Gods wore watch-chains,' he was fond of saying. Under the pressure of strong aesthetic feeling, would not a love of beauty combine with archaeological exactitude to form a philosophy of ornament? One day Moreau asked Degas: 'Are you really proposing to revive painting by means of the dance?' Degas parried: 'And you, are you proposing to renounce it with jewellery?' He might also have been thinking of Wilde's *Salomé*. One can imagine what he would have thought of the Hollywood epics that reduce the Bible stories to so many yards of sequins and temple dancers.

The same degree of perception was brought to bear on the problem of portraying modern life. Degas soon realized that it was not enough to paint people in their ordinary clothes, while adopting a highly traditional type of composition, as he had done in his *Self-Portrait* of about 1855 (Louvre), which had been based on

a romantic Ingres *Self-Portrait* of 1804 (Musée Condé, Chantilly). The whole strategy had to be thought out anew. Changing only the details was rather like introducing colloquial phrases into a play that was still in verse and meant to be performed in the grand manner.

But conversation in real life was full of half-finished sentences and overlapping talk. And was not the same true of appearances? It soon became very clear to Degas that what gives so many of life's actions their final seal of triviality is that they occur simultaneously. If the world had stopped and held its breath while the woman in the café took a sip from her drink (Plate 24), it would indeed have become an act to set beside the crowning of kings. But the world does not stop, it goes on, and the woman is barely noticed by the man smoking his pipe. One dancer yawns at precisely the same moment as another scratches the back of her neck (Plate 15); and both appear oblivious of the ballerinas who are actually dancing. The clerk works at his ledger – unaware of the man reading a paper, who in turn ignores his elderly colleague busy feeling the quality of the cotton (Plate 17). Simultaneous action was not a new idea in painting, but in the art of earlier centuries it had often been geared to religious or mythological illustration, where all the characters react in differing ways to a central event (Leonardo's *Last Supper* is the perfect example), or used as a means of illustrating a general idea ('the unruly school room', 'Gluttony', etc.) in an entertainingly varied manner. Degas stood the idea on its head, by choosing themes without a central dramatic point (the ballet *rehearsal* rather than the full-scale performance, the horses on the track rather than the race itself) and by adopting an angle of vision that reduces the significance of the event (the café singer seen, as if by chance, above and beyond the obtrusive outline of orchestra and audience – Plate 26).

Trivial events, gestures and movements, the sigh of weariness (Plate 38), the pressure of the hand on the iron (Plate 37), an habitual pose with the face resting against the hand (Plate 34), the singer in full song, black-gloved hand expressively poised (Plate 27) – they were all real enough, but were they compatible with art? Degas thought they were, though the same analytic cast of mind that led him to probe deeply into the problems of naturalistic representation made him unusually conscious of the dangers to which naturalism so easily gives rise. Unlike certain modern artists, Degas never imagined that one might achieve an even greater degree of realism by breaking through the very barriers of style itself. 'One sees as one wishes to see,' he once remarked, 'and it is that falsity that constitutes art.' The philosophy of a Marcel Duchamp would have shocked and bewildered him.

Nor did Degas imagine that naturalism would immeasurably broaden the scope of art. The apparent variety that it seemed to imply was really a symptom of its greatest potential weakness, triviality. Degas was only too well aware of the trap into which so many popular artists fell in their never-ending search for novel subjects to please a public that was frivolous and easily bored. 'Instantaneousness is photography, nothing more,' we find him writing in a letter of November 1872. A few days later, in a letter to his friend Henri Rouart, he expressed the view that 'one loves and gives art only to the things to which one is accustomed. New things capture your fancy and bore you by turns.' He touched on the point again in a letter written in January 1886 to Bartholomé: 'It is essential to do the same subject over and over again, ten times, a hundred times. Nothing in art must seem to be accidental, not even movement.'

Like the Renaissance artists whom he so much admired, Degas believed in the perfectibility of a visual idea. Through study, analysis and repetition an image could be made stronger and more inevitable; everything must be made to seem necessary both to the vision and to the design. At the real Café des Ambassadeurs what would have been important would have been the performance on the stage. The fact that the top of the double bass was visible over the heads of the orchestra should have been totally irrelevant; it was not what one had paid to see; though one might have been marginally, almost subliminally, aware of it. Degas seized on just this point: what might be irrelevant to a scene, judged by conventional and in many respects artificial standards, could actually be used as a hallmark of its truth to life. And so, in the painting (Plate 26), the top of the double bass is given a key position in the design, its curves in visual harmony with the shape of the singer's red skirt. In a similar way, in a famous series of paintings of ballet performances seen from the vantage point of the front stalls, Degas wittily challenged the notion that audiences sit through a performance in rapt attention by showing people looking through opera glasses at the boxes. Degas went to the opera, ballet and theatre frequently, and he knew perfectly well that the artistry the performers laboured to perfect (Plates 11, 15, 19, 20, 44, 46) was often thrown away on customers who were bored, restive or ignorant, and who had gone in the first place because it was the thing to do or because they wanted to catch a glimpse of the dancers' legs.

To Degas, with his traditional training and admiration for the wholeness of Renaissance art, its complexity concealed beneath a unified surface, it became very clear that 'irrelevance' could only be made to work, artistically, if it was seen to be essential to the conception and design of the work of art. The *Portrait of Estelle Musson De Gas* (Plate 3) seems particularly 'true to life' because the features have been accurately recorded and because the design is dominated, not by the figure of the lady, the ostensible subject of the picture in the first place, but by the obtrusive but nonetheless visually effective vase of flowers on the right.

Some of Degas's earlier naturalistic works, such as *The Dance Foyer at the Opéra, Rue Le Peletier* (Plate 11), *The Ballet Rehearsal* (Plate 15) or *The Cotton Market* (Plate 17), while brilliantly painted and rich in well observed detail, are slightly over-full. Later pictures are less crowded, and Degas makes greater play with fewer motifs, as may be seen by comparing the trio just listed with the *Two Laundresses* (Plate 38), *The Millinery Shop* (Plate 39) or almost any of the late Bathers (Plates 40–43). He even used an empty floor or patch of ground as a visual symbol of irrelevance; this explains the undue prominence given to the stage in Plate 32 and to the grass in Plate 33.

Always at the back of Degas's mind was a precise combination of lines and colours, and arrangements of form, that would combine the firmness and inevitability of classical design, the basis of Greek and Roman art and the painting of Raphael and Leonardo, Titian and Poussin, with an impression of life that was immediate and spontaneous. Degas devoted a very large part of his career to the difficult task of preserving the disciplines and poised effects of the best kind of traditional art while rejecting its time-honoured associations, props and subject-matter. Paul Cézanne once said that he wanted to make of Impressionism something solid and durable, like the art of the museums. Degas would have agreed with him. Characteristically, he summed up his position in an epigram: 'Ah, Giotto, don't prevent me from seeing Paris; and, Paris, don't prevent me from seeing Giotto.'

In an earlier century, the female figure hovering in the air, and seen from below, would probably have been the Virgin Mary at the moment of her Assumption. In Degas's composition (Plate 31), which is contrived with all the skill and artistry of an Old Master, she is a circus performer swinging by her teeth. And nothing could be less obviously idealized, less like the figures of Ingres in fact, than Degas's studies of the female nude (Plates 40–43 and 48). The artist himself told the Irish writer George Moore that they represented 'the human beast occupied with herself, a cat licking herself', and they create a realistic impression because we are shown women who have undressed not for our admiration but to wash their bodies. The comparison with Renoir is instructive. In his nudes, Renoir usually shows the face, which is the key to intimacy, and his lusciously pretty girls even look invitingly at the spectator. Degas avoids the face and usually prefers a back view of the figure, thus heightening the illusion of a true-to-life glimpse. The sense of actuality is increased by compositional devices, the view through an open door, perhaps, or the choice of an unusual angle (Plates 42 and 43).

Renoir painted away, year after year, and his skill and love of life, his vulgarity and dreamy optimism, the erratic drawing and faulty space composition, the weakness for rainbow colours, they are all right there on the canvas. Nothing has been held back, there is nothing in reserve; even with the major paintings you are made to feel that this is absolutely the very best he could do. But study a large body of Degas's work for any length of time and a different impression forms. Degas burrowed deep, he was in many ways a very experimental artist, but his achievements have a carefully calculated air of anonymity. The talent and skill seem somehow masked so that, even in elaborate pictures (Plates 4, 5, 11, 15, 17 or 20, for example), he never appears to be at absolutely full stretch. Like Leonardo, Degas suggests a mastery that goes far, far deeper than anything that can actually be seen on the surface and yet which seems to control, as from a great distance or great height, every detail of what is there on paper or canvas. Renoir went from canvas to canvas and, if it was a good day, a good painting would emerge, but one seldom senses any purpose larger than the context of the moment. With Degas, however, working away on the same limited number of themes (landscape, still-life, flowers and animals, apart from horses, rarely appear in his work), and using the same figures in the self-same poses over and over again, one has an impression of long-range planning and iron determination. There are times, indeed, when Degas's enormous oeuvre almost seems like the preparation for some heroic undertaking that never actually materialized.

It was this strange and impressive artistic sensibility, precariously poised between an aesthete's disgust and passionate curiosity about life, that Degas brought to the time-honoured theme of the female nude. Without sacrificing one jot of their everyday ordinariness, he was able to invest the bodies with the monumentality of ancient sculpture; his figures have that sense of being individual and yet, at the same time, impersonal, which is a hallmark of so much Antique art. Renoir once compared these works (Plates 40–43) to fragments from the Parthenon, the noblest creation of fifth-century Athens.

In art observation will go for nothing unless it is related to design. And it was this underlying discipline of classical design that Degas so admired in the paintings of Ingres. He never allowed himself to forget the lesson of Ingres. It was constantly, vitally relevant, precisely because his own kind of naturalism was so radical, committed

to showing not only what is actual and unidealized (seventeenth-century Dutch painters had already done this) but also how it *appears* to the eye (which few Dutchmen had attempted). So far-reaching a proposition raised, and still raises, the question of what is meant by 'true to life' and how 'casual' and 'significant' should be defined. When, in daily life, we notice something 'casually', we make a lightning judgement according to standards of what is significant. For any one of a thousand accidental reasons, other people's lives impinge upon our own; we are made aware of a gesture, a movement, a figure, and just for a moment it occupies the forefront of our attention. But we soon dismiss it again if it does not pass the test of what is personally important to us. A woman in black, kneeling in prayer, with tears streaming down her face, is likely to make a deep impression because she brings to mind profound associations of death and loss. And she might also stand, incidentally, for a type of recognizably emotive image favoured by the older and more traditional schools of art. But a woman merely yawning (Plate 38), a man smoking a pipe and evidently thinking about something else (Plate 24) or a girl leaning over a table and resting her body on her crossed arms in a pose that every single human being must have adopted at some moment (Plate 36), they are all visual phenomena too ordinary to lodge themselves in the memory; and they merely take their place in the passing flow of impressions which make up the richly varied yet curiously vague texture of daily life.

Degas's great achievement lay in his ability to render that texture in wholly pictorial terms. The life-like casualness of his 'impressions' is defined not through implicit appeals to our non-pictorial faculties of judgement, as it is in Victorian anecdotal painting, where even the titles *(The Morning Gossip, A Passing Thought)* stress the story, but by pure design. On the right of *The Rehearsal* (Plate 20), the wardrobe-mistress is repairing or adjusting the skirt of a dancer. It is an action of no intrinsic importance; and that is what, by virtue of his art, Degas allows it to remain. The instinctive human process of attention, judgement and dismissal is transmuted into a pictorial device, whereby the group is deliberately cut into by the edge of the picture. Move the whole group to the centre of the canvas and it would assume, because of its dominant position in the design, a 'non-casual' importance; and the pictorial situation might become pregnant with just those narrative implications that Degas was at pains to avoid.

There are of course difficulties. The kind of impersonality that Degas achieved goes against what many people want from art, it is the enemy of what is cosy and friendly, touching and pretty, and it is not surprising that his work has been misinterpreted in the usual kind of terms that people are still accustomed to apply to works of art. 'L'Absinthe' (Plate 24) was violently attacked in the 1890s for its alleged obscenity, as if it had been deliberately created to shake people out of their complacency, like Ibsen's *Ghosts*, whereas in reality it is a painting of a couple in a Parisian café, the woman merely lost in thought. And the very fact that Plate 36 has always been known as '*The Reading of the Letter*' is a minor example of the same literary, dramatizing principle at work. For what is surely happening in the picture is that two laundresses are having a rest, and one of them is cooling herself with a makeshift fan. Plate 36, like so many of Degas's works, is not about a significant event but about physical behaviour. And design, with all its implications of selection and emphasis, is at the centre of Degas's achievement. For it enabled him, at one and the same time, to re-create an impression of unaccented, flowing life and to preserve a purely aesthetic harmony that is not haphazard at all –

and without which the very power of the vision would be lost. Degas created unforgettable images of unmemorable facts; and in this light his art, representing as it does a tolerant acceptance of life, takes on a moral dimension.

Degas's life was not in itself very eventful. He had private means and did not need to court either popularity or customers. He never married. Between October 1872 and April 1873 he was in America, visiting his brothers in New Orleans; the most important artistic result of the trip was the painting of the New Orleans Cotton Exchange (Plate 17). On his return to Paris Degas settled in a studio in the Rue Blanche, where he concentrated on themes from modern life, often connected with some form of professional skill: dancers, acrobats (Plate 31), jockeys (Plates 9 and 10), singers (Plates 26 and 27), musicians (Plate 13), milliners (Plate 39) and laundresses (Plates 36–38). To this list he soon added the female nude, which became, with dancers, his favourite subject-matter in later years.

To the group show mounted by the Impressionists in 1874 Degas contributed ten works; and he exhibited at all the others, save for that of 1882. In 1881 he showed the *Little Dancer of Fourteen Years* (there is a cast in the Tate Gallery), the only one of his sculptures exhibited in his lifetime. After 1886, the year of the eighth and last Impressionist group exhibition, Degas stopped sending works to public shows. His eyesight was by now very poor, and he worked more and more in pastel, a medium he found susceptible to bolder effects than oils.

Degas was concerned with the underlying structure of design and form from the very beginning. Already, in 1856, we find him writing in a note-book: 'It is essential, therefore, never to bargain with nature. There is real courage in attacking nature frontally in her great planes and lines, and cowardice in doing it in details and facets.' Even when copying the great artists of the past, as an exercise, Degas was faithful to his maxim, blocking in the forms broadly and ignoring minute details. *The Young Spartans* (Plates 5 and 7), or a portrait like the *Estelle Musson De Gas* (Plate 3), reveal the same approach to form. And it is also evident in the double portrait of the artist's sister, Thérèse, and her Italian husband, Edmondo Morbilli, whom she married in 1863 (Plate 8). The picture was probably never finished; and the disfiguration across the woman's body was no doubt caused by Degas scraping away what he had done in dissatisfaction.

The composition of the portrait is of great interest in that it shows one of the ways in which Degas attempted to reconcile harmonious classical design with the conclusions that he made from his observation of actual behaviour. Thérèse Morbilli sits conventionally enough at one end of an Empire sofa in an ordinary sitting-room; but her husband casually balances on the back of the sofa, turning to look, as she does, in the direction of the spectator. The pose would have been thought much too informal and precarious by traditional portraitists, but these were precisely the qualities that Degas prized for their life-giving values. The increasing vitality and imaginative force of Degas's portraiture may be judged by a simple comparison between the very early picture of Achille De Gas (Plate 2), formally posed against an almost neutral background, and the two very important 1879 portraits of champions of the new painting, Diego Martelli (Plate 35) and Edmond Duranty (Plate 34), shown in ordinary working clothes in their own environment. Both are masterpieces of calculated informality. Even the much earlier picture of the Morbillis has an immediacy alien to a portraitist like Ingres, the suggestion of people suddenly asked,

in the middle of the afternoon, to look in the artist's direction for a minute or two while he paints them.

In working out formulae that would accommodate this spontaneous fragmentary aspect of vision, Degas was influenced by Japanese prints, which had become both popular and fashionable in the early 1860s, and by developments in photography. From the colourful prints of Japan, he learned how to cut off the figure abruptly (for example, the man on the right in Plate 22 or the dancer on the right in Plate 20); how to achieve effects through calculated asymmetry (Plates 31, 32, 33); and how to make use of the bold close-up (Plate 27). The sloped foregrounds in his work (Plates 32, 33, 35) and unusual sight angles (Plates 13, 21) suggest the influence of photography, an art in which Degas was himself a proficient amateur.

Visual spontaneity, however, was not achieved at the expense of visual equilibrium. Again under the impact of Japanese prints, which do not conform to Western traditions of box perspective, Degas learned to use void areas positively. The grass in the *Jockeys before the Race* (Plate 33), for example, or the boarded floor in *The Rehearsal* (Plate 20), even the table tops in '*L'Absinthe*' (Plate 24), tell not only as surfaces receding into depth but also as flat shapes whose very simplicity is a counterweight to the figures.

The crucial link between the flux of life and the unfluctuating sense of order that Degas felt was proper to art lay in design, which in turn depended on drawing – the lines, the many lines Ingres had urged him to draw. Degas shared the general Impressionist interest in the effects of light, and he could render them with the greatest delicacy and precision (Plates 16, 20, 27, 32); he knew the value of light, and how it could be made to reveal form (the arms of the singer, for example, in Plate 26) and emphasize movement (Plate 18), but he would never allow the observation of light to undermine the importance of drawing. Even when the forms are seen under a powerful illumination, the outlines in Degas's paintings are always firmer than those of Monet, Renoir or Pissarro. And Degas would make preliminary sketches of figures which, in the final painting, might be subjected to entirely different methods of lighting. For *The Rehearsal* (Plate 20) four beautiful drawings have survived; and in some even a plumb-line was used. To describe a painting like this as a 'slice of life' created with the patient subterfuge of the Old Masters is to underline what the artist once told George Moore: 'No art was less spontaneous than mine. What I do is the result of reflection and study of the great masters; of inspiration, spontaneity, temperament, I know nothing.'

A feeling for order depends on having a sense of priorities arrived at through evaluation. Drawing was Degas's method of evaluation. Pastel always appealed to him precisely because it enabled him to retain colour without giving up a linear emphasis. In one of his most illuminating remarks, Degas explained why it was important that the artist should not draw only what was directly in front of him. 'It is all very well to copy what you see,' he said, 'but it is much better to draw only what you still see in your memory. This is a transformation in which imagination collaborates with memory. Then you only reproduce what has struck you, that is to say the essential, and so your memories and your fantasy are freed from the tyranny which nature holds over them.' Degas is one of the great draughtsmen in the history of European art, and the constant exercise of this great gift on a restricted range of subject-matter enabled him to judge, with increasing sureness, what could and could not be eliminated in any sequence of forms. The girl combing her hair, on the left of Plate 29 (about 1875–6), is an exquisitely observed figure:

look at the placing of the hands and arms, and the way in which the head is forced slightly to one side by the downward pressure of the comb drawn through the hair. Yet the study remains highly simplified. The tiny irregularities, the bumps, veins and wrinkles in hand and arm have been suppressed. But it is precisely this careful selection of the forms which gives to those that are finally included their conviction and simple grandeur. *Combing the Hair* (Plate 45) dates from about fifteen years later and it carries the process of monumental simplification a stage further. So sure is the drawing that the image seems naturalistic even though the colouring is highly artificial.

Degas also valued drawing because line and outline are among the most satisfactory methods of creating an illusion of movement – the movement on which he always concentrated because for him it vividly expressed the pulse-beat of life. True to the Impressionists' anti-literary doctrine, Degas tried to achieve the maximum expressiveness of form and complexity of movement with the minimum of narrative association. The paintings inspired by the ballet – the most popular and in some respects the least understood category of his work – exemplify his aims; and a copy that he made about 1870 in the Louvre of Poussin's *Rape of the Sabine Women* (about 1635–7) helps to make the point even more clearly.

In the Poussin copy, across a setting that is itself not unlike the stage of a theatre, carefully placed groups of figures display the whole gamut of emotions implied by a concerted attack. Degas himself, in his maturity, did not paint such a scene. But in the dancer, the laundress, the jockey, the acrobat, the milliner arranging her hats, the woman at her toilet, he found a corresponding range of bodily movement. He was particularly attracted by the exercise of a professional skill in which highly conscious and often severely disciplined actions were brought into play for professional rather than personal reasons. As she pirouettes and glides across the stage, and raises her expressive arms, the dancer is not Daphne eluding the amorous Apollo, or a Sabine resisting her earnest captor; but neither is she a dramatic character in a ballet; she is simply a dancer doing her job. In one complex operation, Degas, like Daumier in his theatrical scenes, preserves the trappings or artifice while stripping away the pretence.

Of all the painters loosely grouped together under the name of Impressionists, Degas most deserved a great final phase of creative activity. But though he laboured on, he was denied through failing sight an ultimate flowering of his great gifts. The last twenty years of his life were wretched. His eyesight deteriorated still further in the 1890s; and in the early years of the new century he could only work, and then with difficulty, on large compositions or sculpture that he could model with his hands, by touch. In 1908 he more or less gave up art altogether. The blow was crippling. Degas's life was over. But he went on living, morose, irritable, pathetic, endlessly repeating his old maxims and anecdotes and falling into terrible silences broken by a single utterance: 'Death is all I think of.' Long famous and revered, he died in Paris on 27 September 1917.

The qualities of mind that had helped to make his artistic achievements so exceptional made his last years particularly tragic. As the once sure hand, as sure as any since Leonardo da Vinci, Holbein or Rembrandt, fumbled with the chalks, no wonder he railed at fate. He knew, so clearly, what he wanted to do. Unable to do it, his life became barren, aimless, a terrifying fog illuminated only by the glimmer of memories. As he shuffled along the boulevards 'in his Inverness cape, tapping his cane, feeling his way', oblivious to the sounds of the motors and frequently

in danger of being run over, how often his mind must have gone back over half a century to that unforgettable meeting with another great artist, then also old, and to the advice he had given: 'Draw lines, young man, many lines. . .'

Outline biography

1834 Born in Paris, 19 July, son of a banker.

1845–52 At school in Paris (Lycée Louis-le-Grand).

1852–4 Begins to study art seriously, under Barrias and Lamothe.

1854–9 Regular visits to Italy, where he studies and copies Renaissance and Ancient Art. In Rome, in touch with the French Academy there.

1859 Takes a studio in the Rue Madame, Paris, and concentrates on portraiture and historical subjects.

1865–70 Contributes regularly to the official Paris Salon (French equivalent of the Royal Academy).

1870 Serves in the Franco-Prussian War. By this date, he is already painting such 'modern' subjects as theatre and orchestra scenes as well as horses and jockeys.

1872–3 Visits his brothers in New Orleans and paints several pictures there, notably the *Cotton Exchange* (Plate 17).

1874 Contributes to the first Impressionist Exhibition in Paris; and to all the others, with the exception of the 1882 show.

1880 Visit to Spain.

1886 Contributes to the last Impressionist Exhibition. After this date, he does not send his work to public exhibitions, though his pictures are shown commercially by Durand-Ruel. By this date his eyesight is very poor and he is working more and more in pastel.

1889 Visits Spain with the painter Boldini.

1912 By this date Degas has become famous and his works relatively popular. *La Danseuse à la Barre* (New York, Metropolitan Museum of Art) fetches $100,000 at auction.

1917 Dies in Paris, 27 September.

List of Plates

15

× 66 cm. Liverpool, Walker Art Gallery.

38. *Two Laundresses.* About 1884–6. Canvas, 73 × 79 cm. Paris, Louvre (Jeu de Paume).

39. *The Millinery Shop.* About 1884. Pastel on paper, 100 × 111 cm. Chicago, Art Institute.

40. *After the Bath: Woman Drying Herself.* About 1885–90. Pastel on paper, 104 × 98·5 cm. London, National Gallery.

41. *After the Bath.* 1885. Pastel on paper, 63·5 × 51 cm. Private Collection.

42. *The Bath.* About 1885–90. Pastel on paper, 70 × 43 cm. Chicago, Art Institute.

43. *After the Bath.* 1883. Pastel on paper, 53 × 33 cm. Private Collection.

44. *Dancers.* About 1890. Pastel on paper, 54 × 76 cm. Glasgow, Art Gallery (Burrell Collection Loan).

45. *Combing the Hair.* About 1890. Canvas, 114 × 146 cm. London, National Gallery.

46. *The Dancing Class.* 1874. Canvas, 85 × 75 cm. Paris, Louvre (Jeu de Paume).

47. *Dancers in Blue.* About 1890–5. Canvas, 85 × 75·5 cm. Paris, Louvre (Jeu de Paume).

48. *Woman Drying Herself.* About 1890–5. Pastel on paper, 64 × 62·75 cm. Edinburgh, National Gallery of Scotland (Maitland Gift).

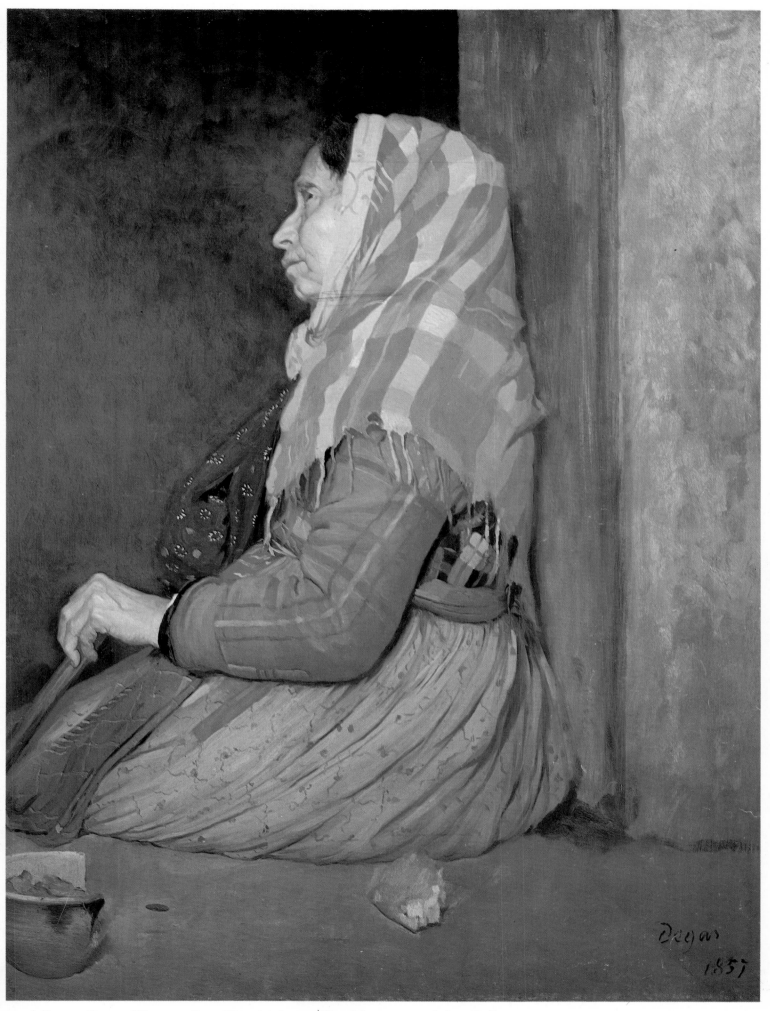

1. *A Roman Beggar Woman.* 1857. Birmingham, City Museum and Art Gallery

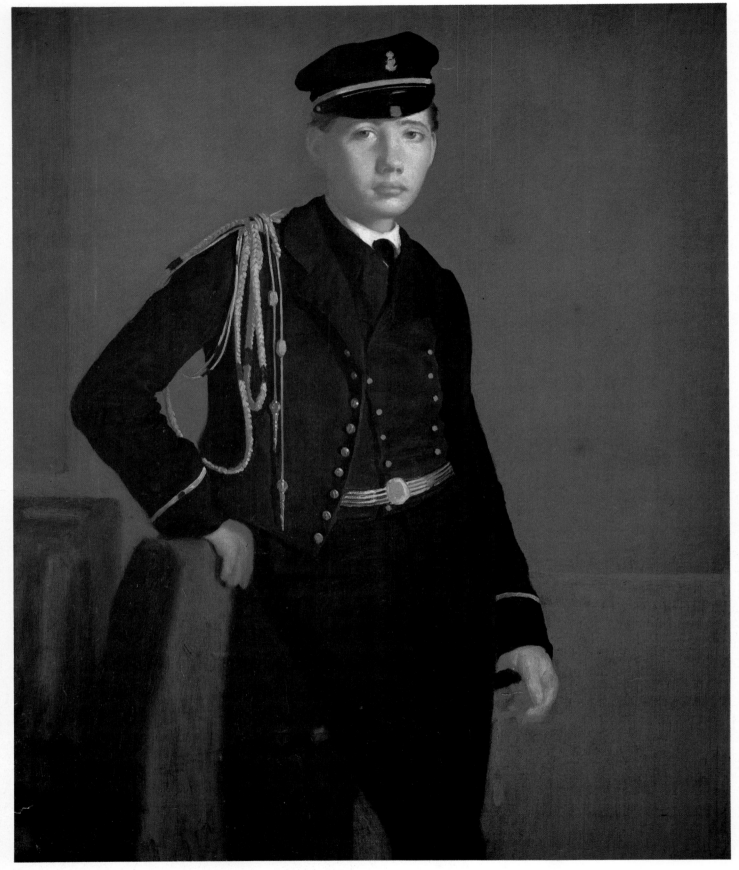

2. *Achille De Gas in the Uniform of a Cadet*. About 1857. Washington, National Gallery of Art (Chester Dale Collection)

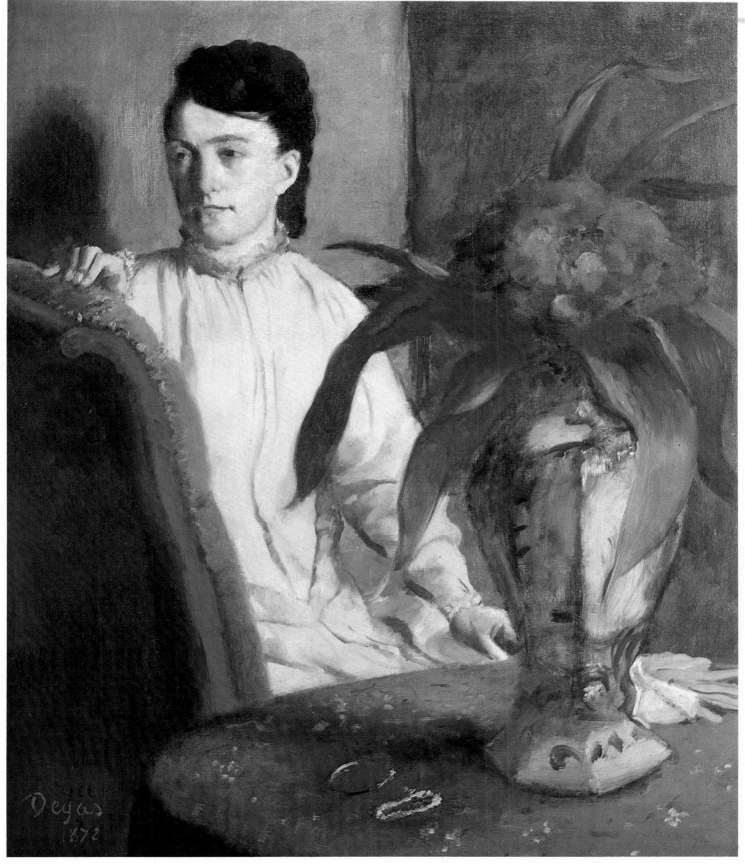

3. *Portrait of Estelle Musson De Gas.* 1872. Paris, Louvre (Jeu de Paume)

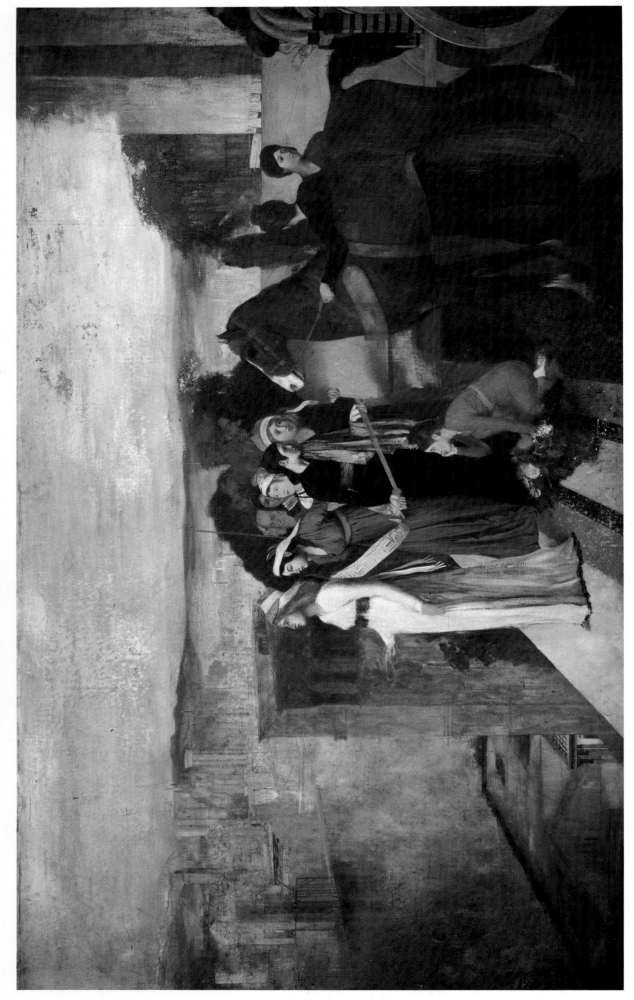

4. *Semiramis Building Babylon.* 1861. Paris, Louvre (Jeu de Paume)

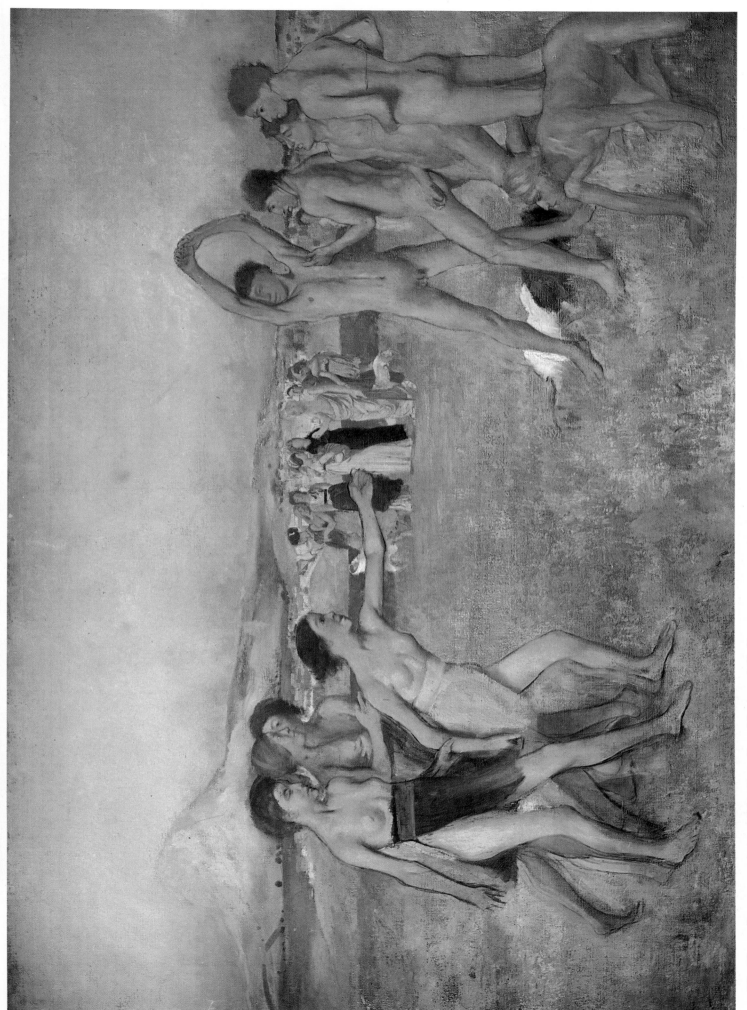

5. *The Young Spartans*. About 1860. London, National Gallery.

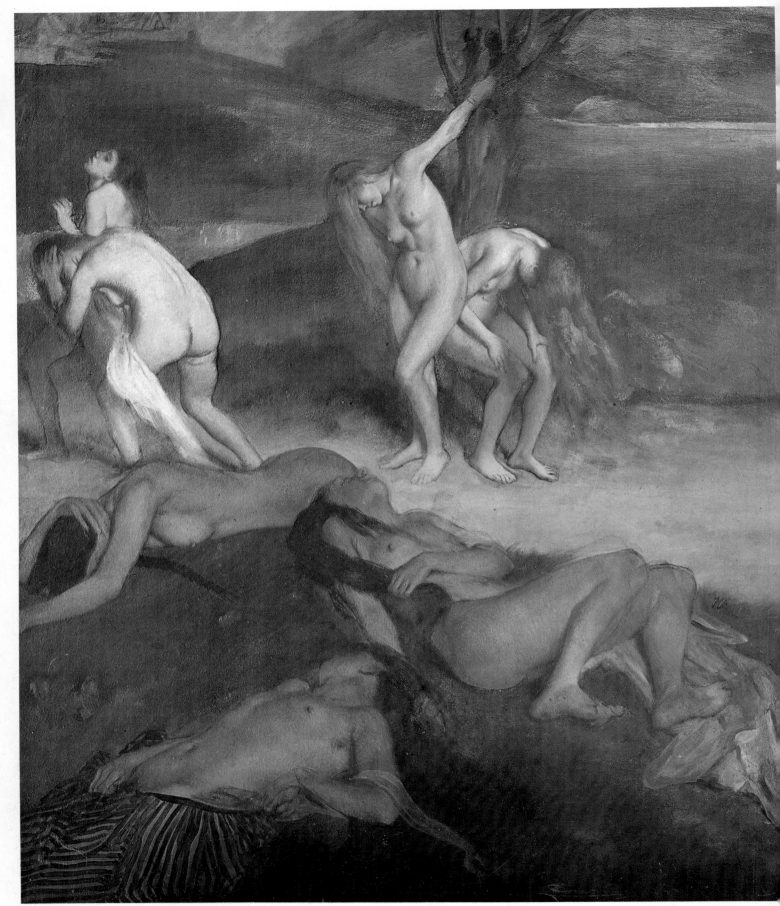

6. *Scenes from War in the Middle Ages* (detail). 1865. Paris, Louvre (Jeu de Paume)

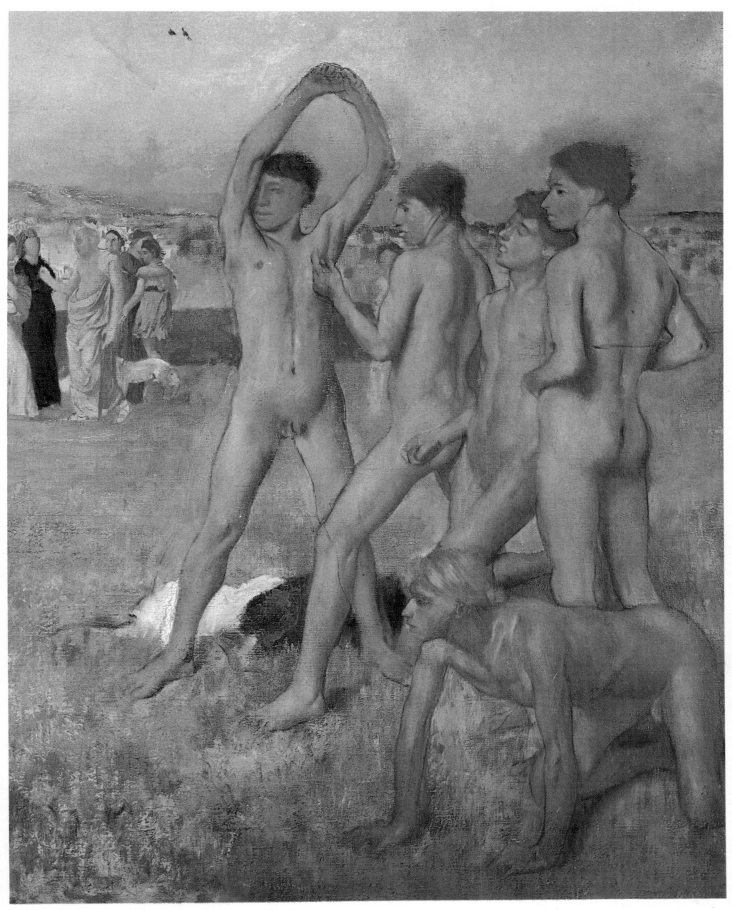

7. Detail of Plate 5

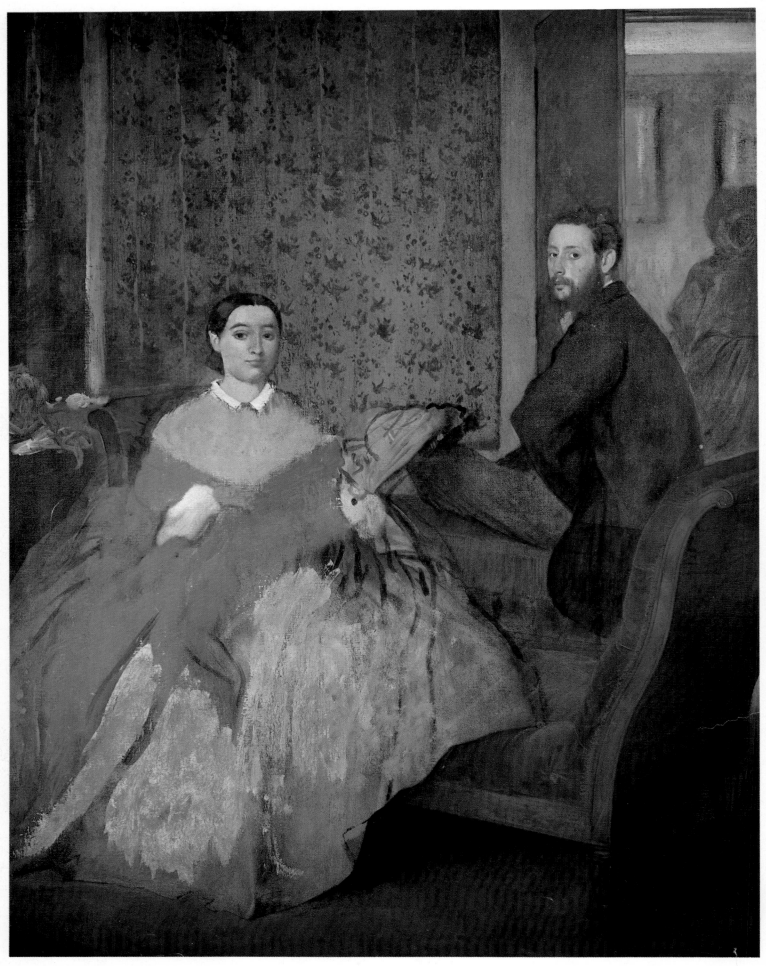

8. *Duke and Duchess of Morbilli*. About 1865. Washington, National Gallery of Art (Chester Dale Collection)

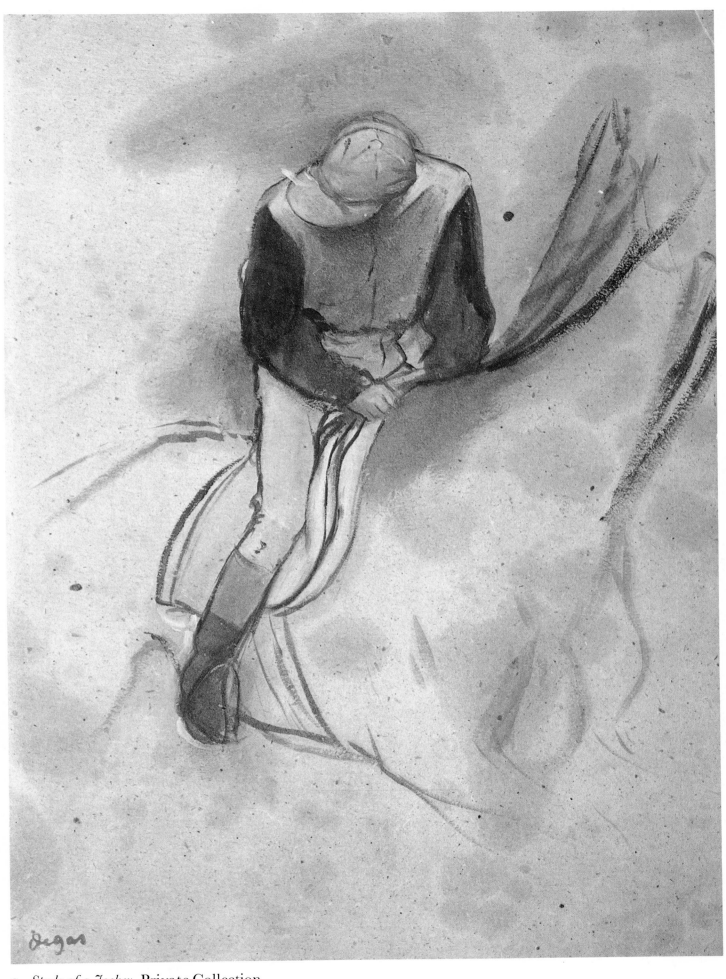

9. *Study of a Jockey*. Private Collection

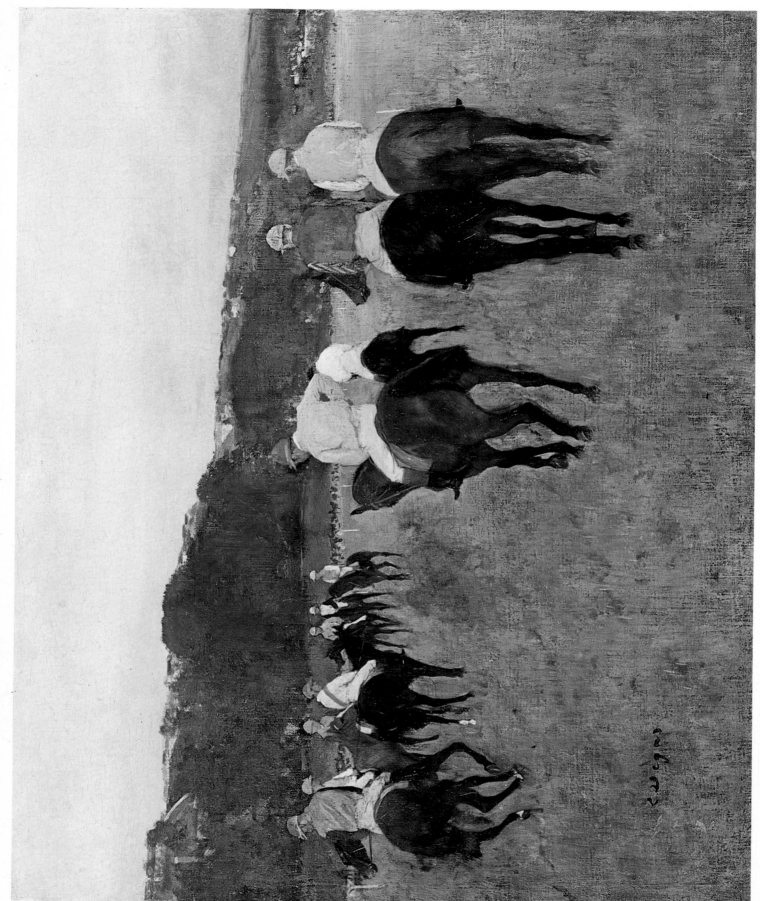

10. *Horses on the Course at Longchamp.* About 1873–5. Boston, Museum of Fine Arts

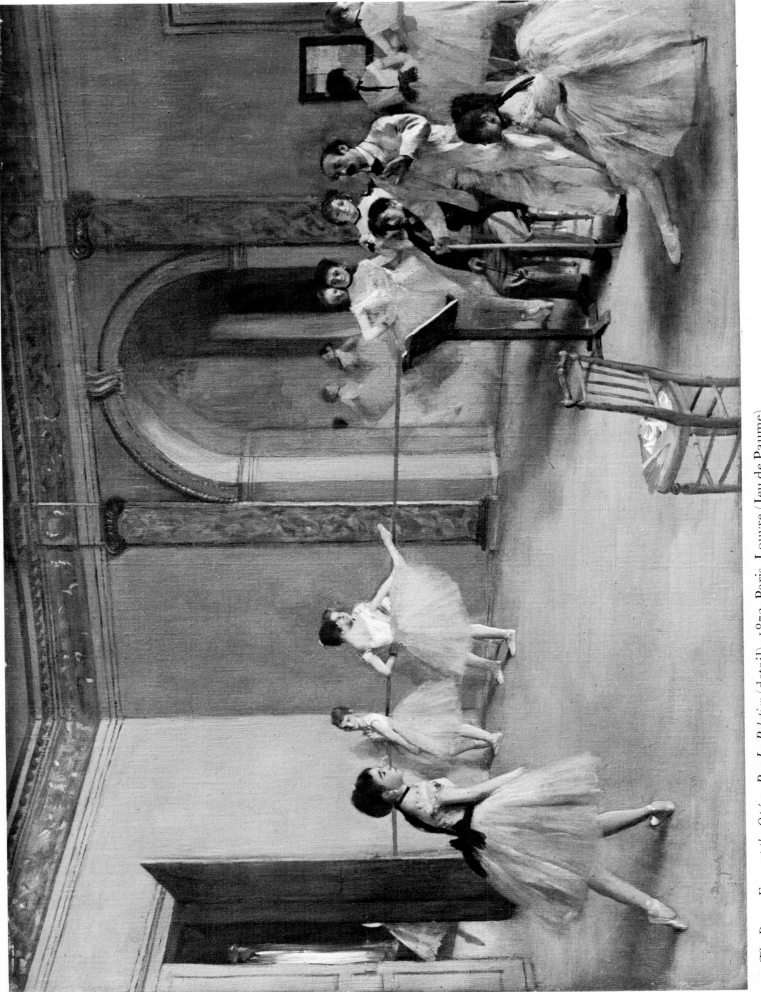

11. *The Dance Foyer at the Opéra, Rue Le Peletier* (detail). 1872. Paris, Louvre (Jeu de Paume)

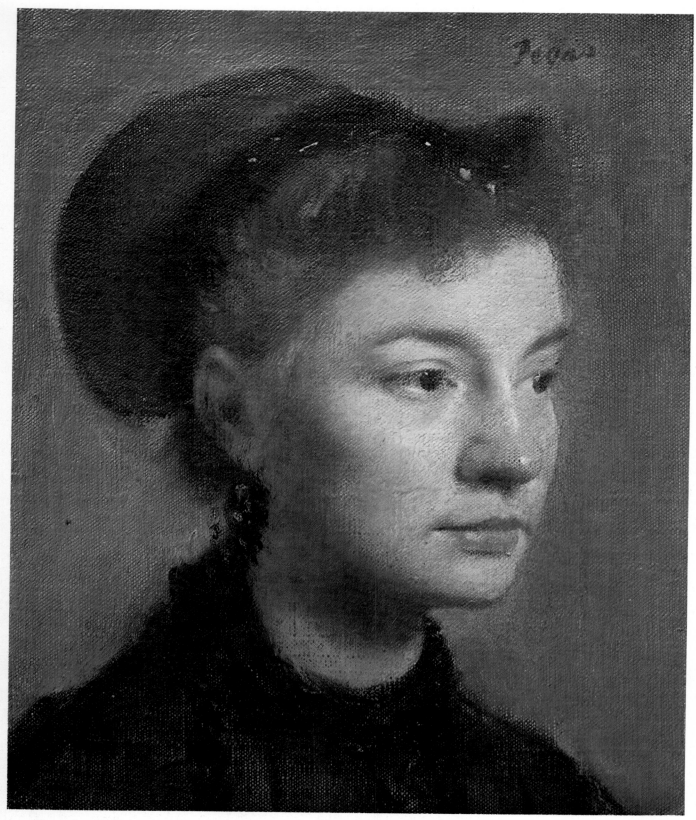

12. *Portrait of a Young Woman.* 1867. Paris, Louvre (Jeu de Paume)

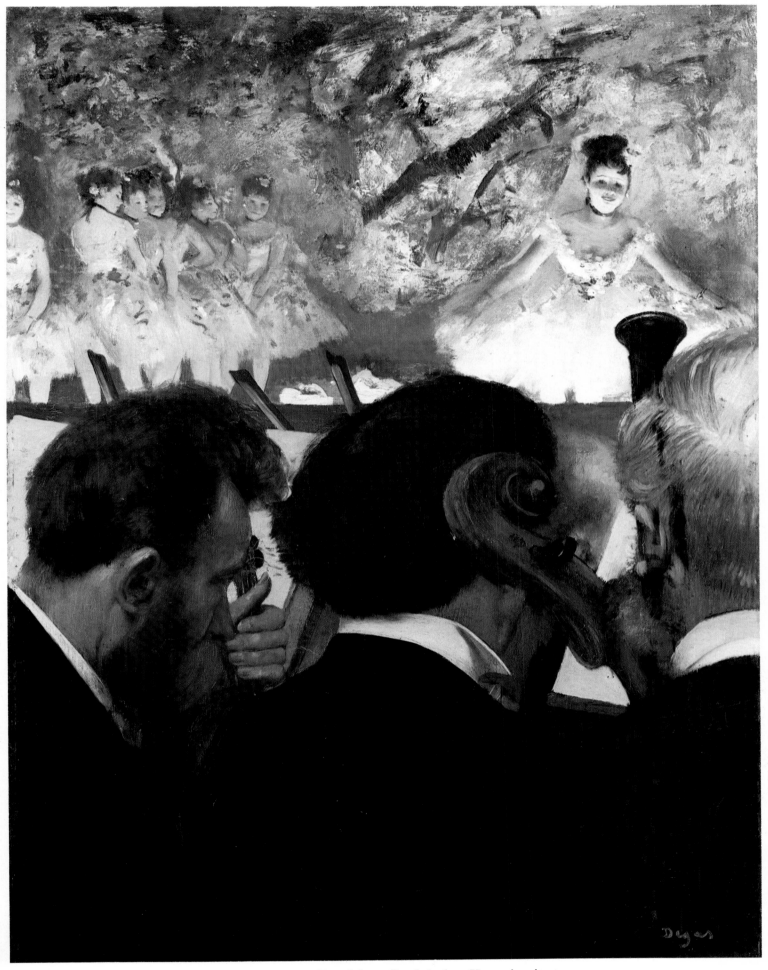

13. *The Musicians in the Orchestra*. About 1872. Frankfurt, Städelsches Kunstinstitut

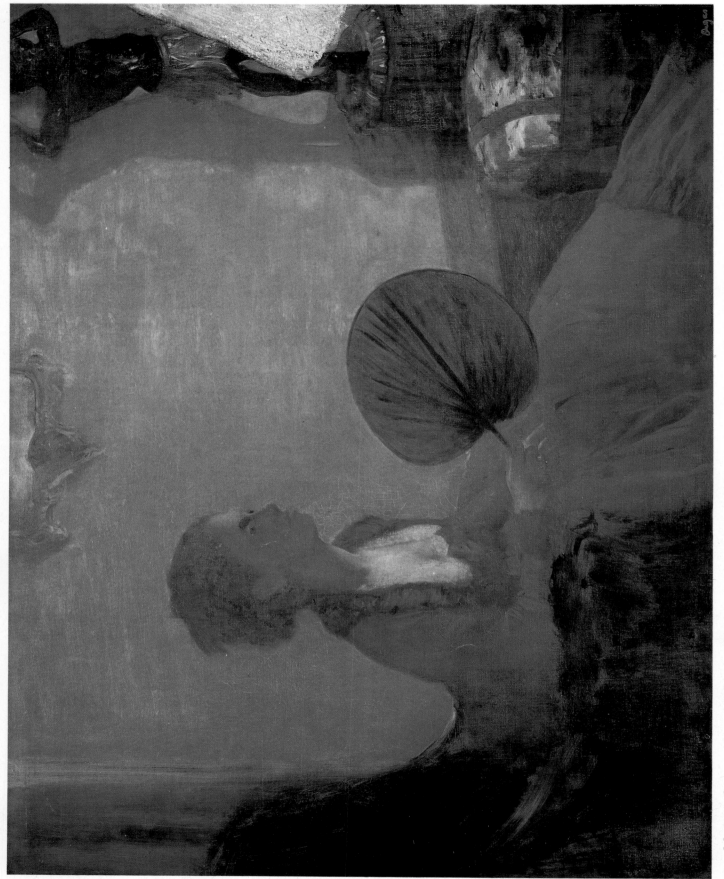

14. *Madame Camus. About 1869–70. Washington, National Gallery of Art (Chester Dale Collection)*

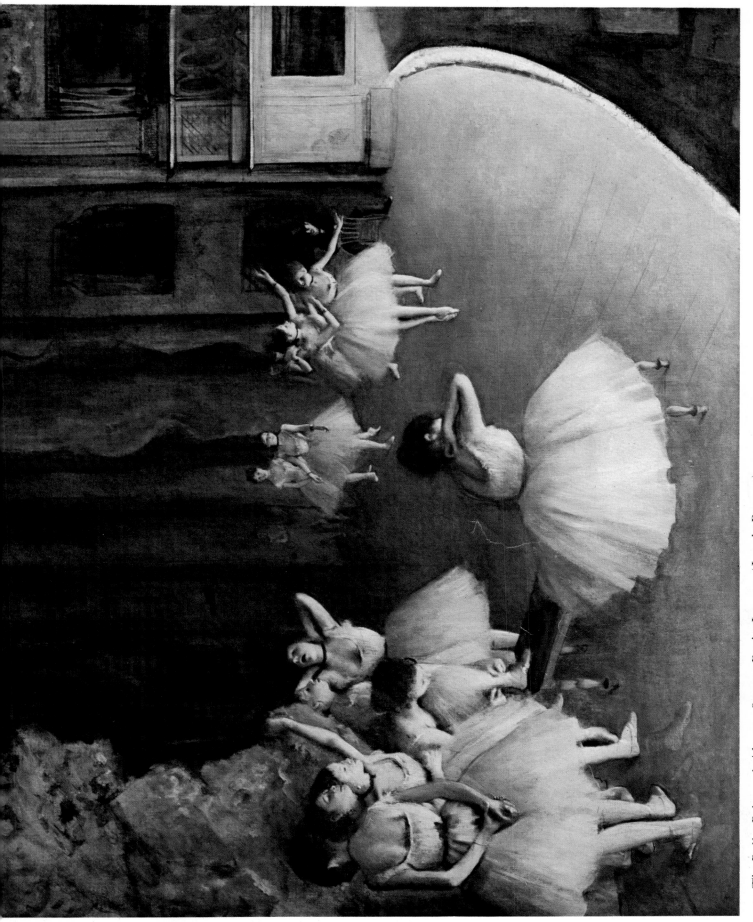

15. *The Ballet Rehearsal.* About 1873–4. Paris, Louvre (Jeu de Paume)

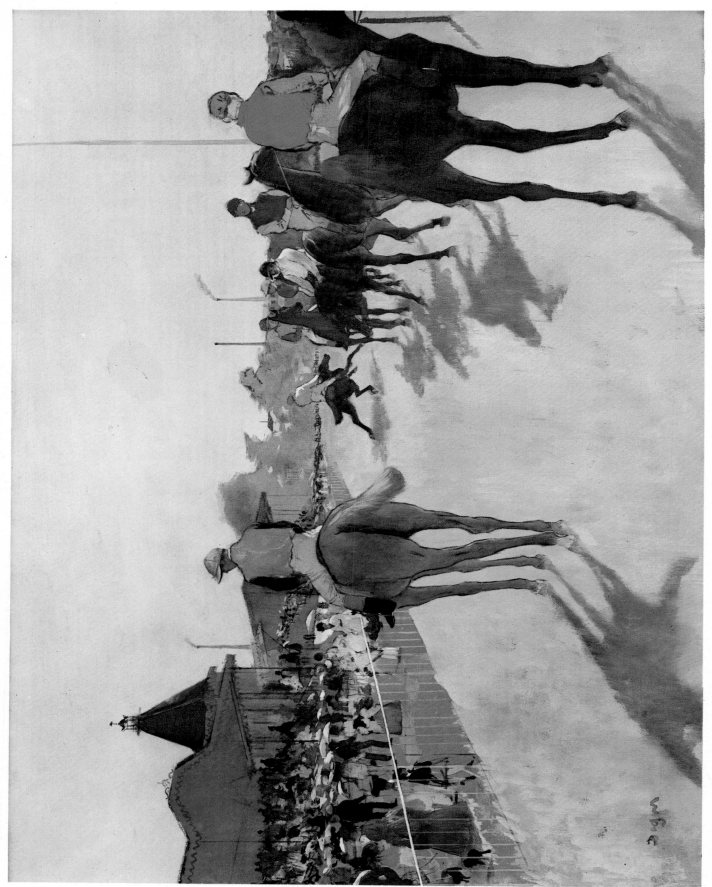

16. *Race Course Scene, with Jockeys in front of the Stands.* 1869–72. Paris, Louvre (Jeu de Paume)

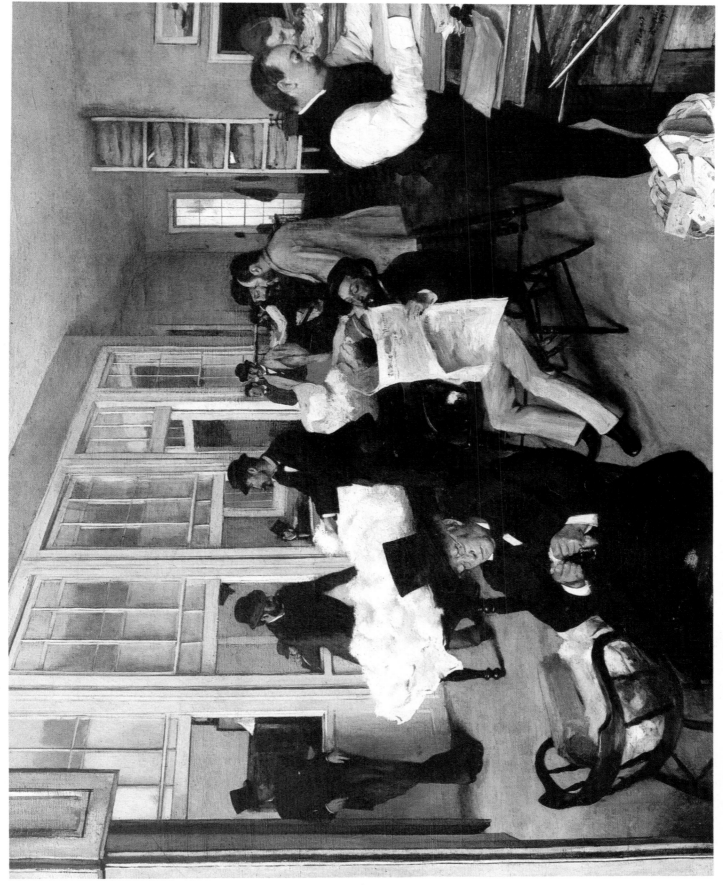

17. *The Cotton Market.* 1873. Pau, Municipal Museum

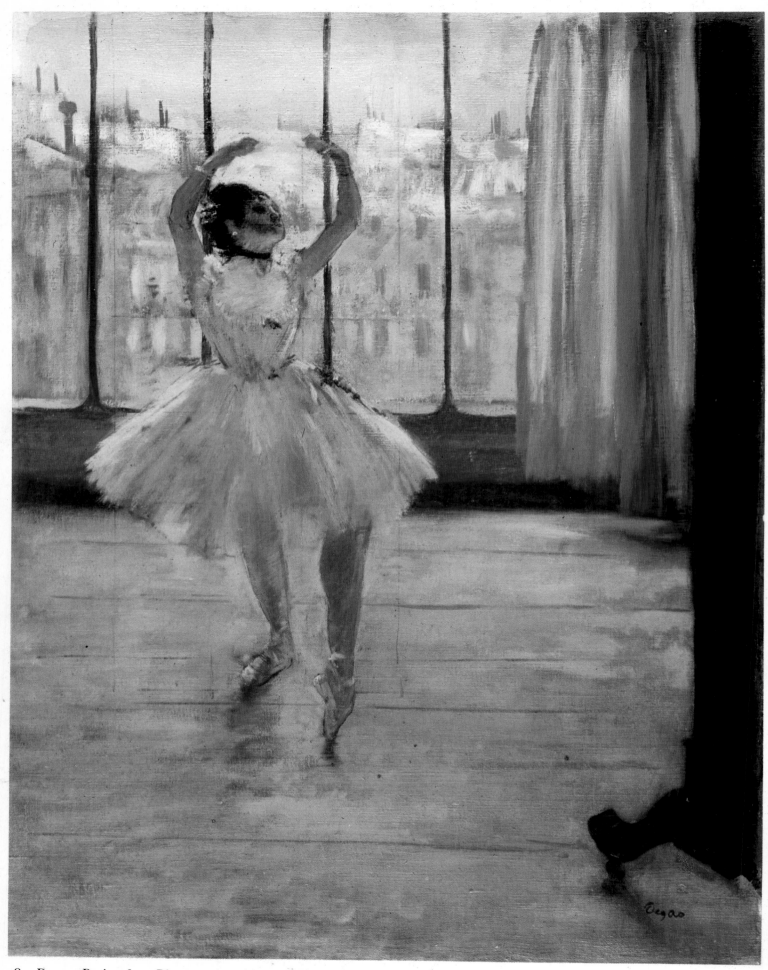

18. *Dancer Posing for a Photographer*. About 1877–8. Moscow, Pushkin Museum

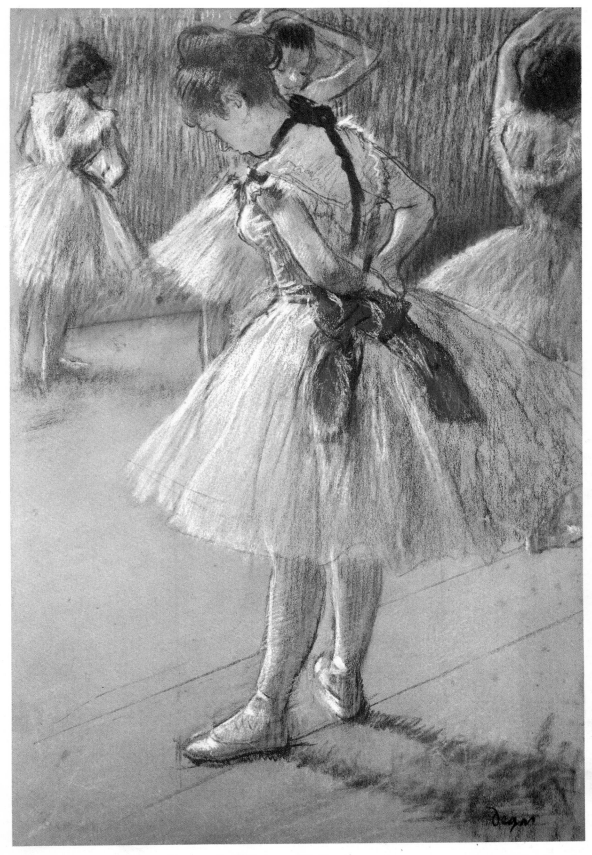

19. *Dancers Rehearsing*. About 1878. Private Collection

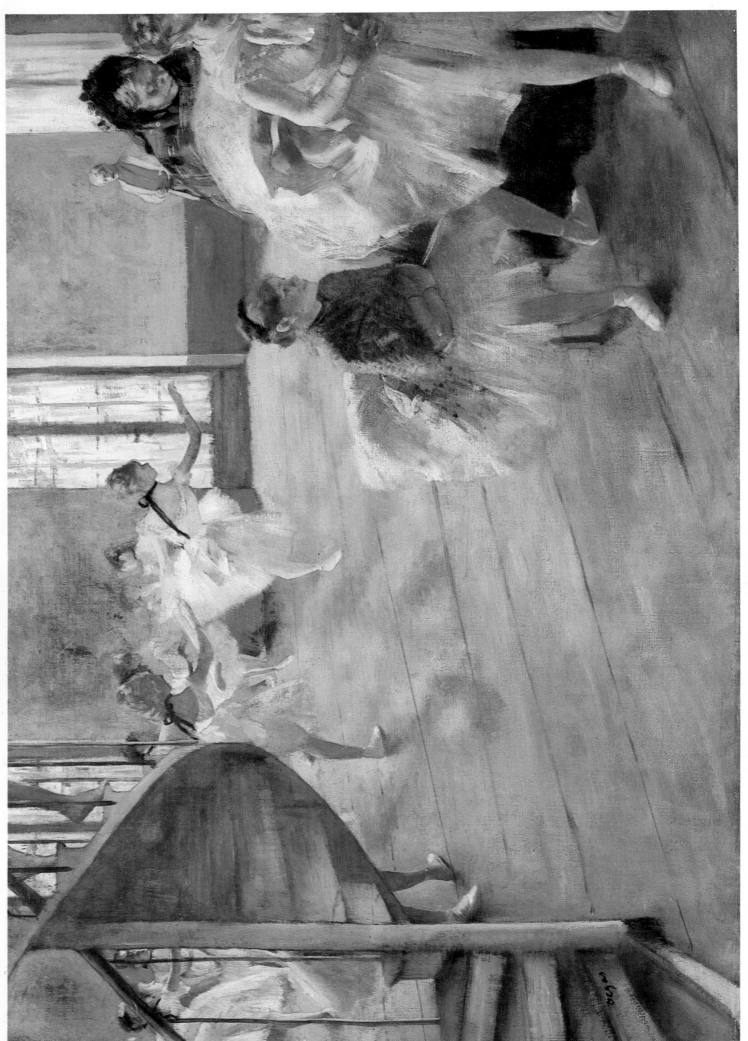

20. *The Rehearsal*. 1873–4. Glasgow, Art Gallery (Burrell Collection Loan)

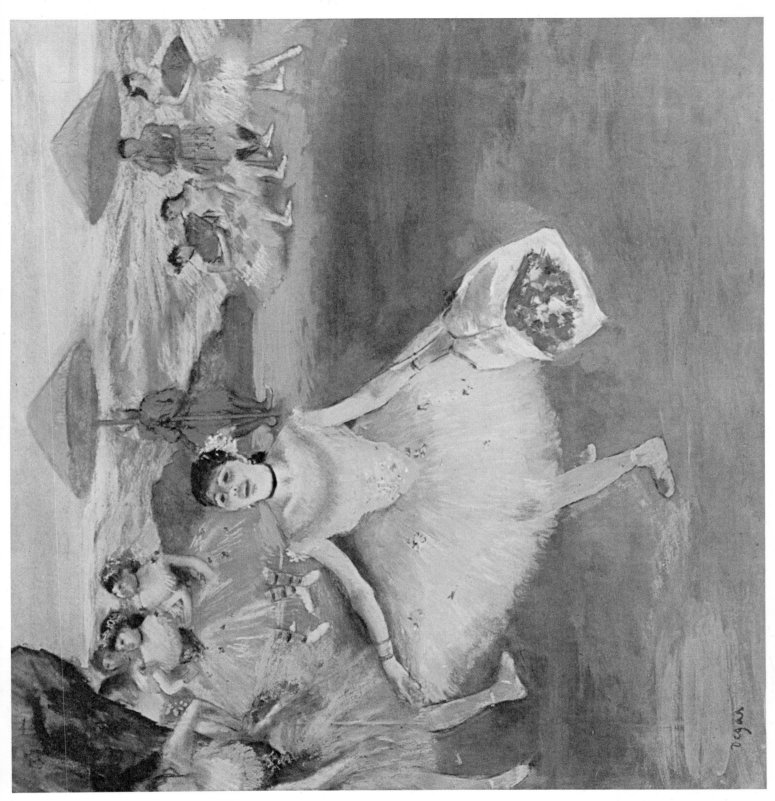

21. *Dancer with a Bouquet Bowing.* About 1877. Paris, Louvre (Jeu de Paume)

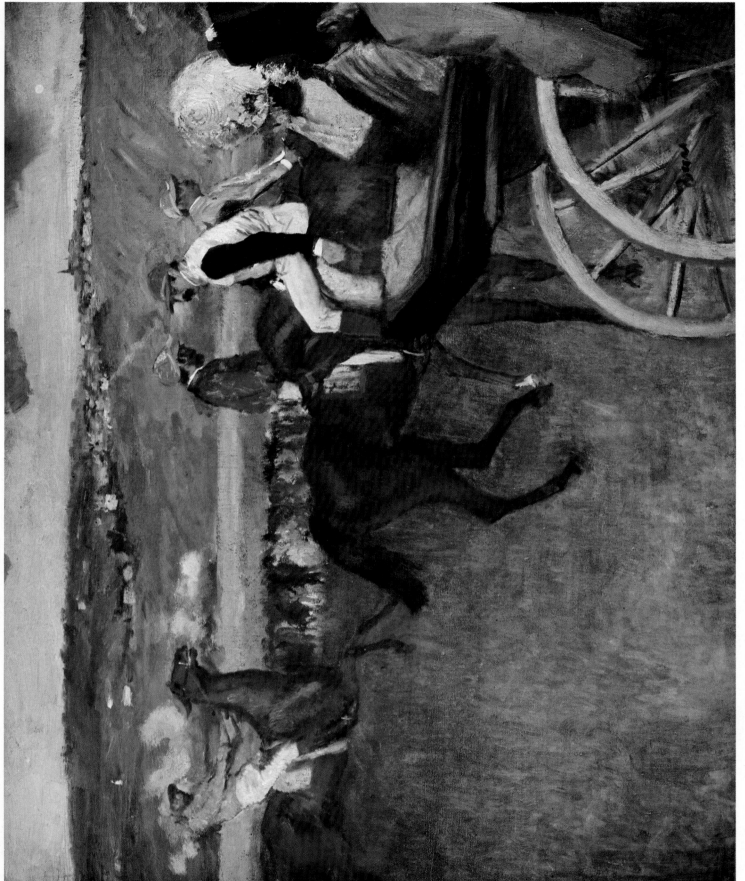

22. *Amateur Jockeys on the Course, beside an Open Carriage.* About 1877–80. Paris, Louvre (Jeu de Paume)

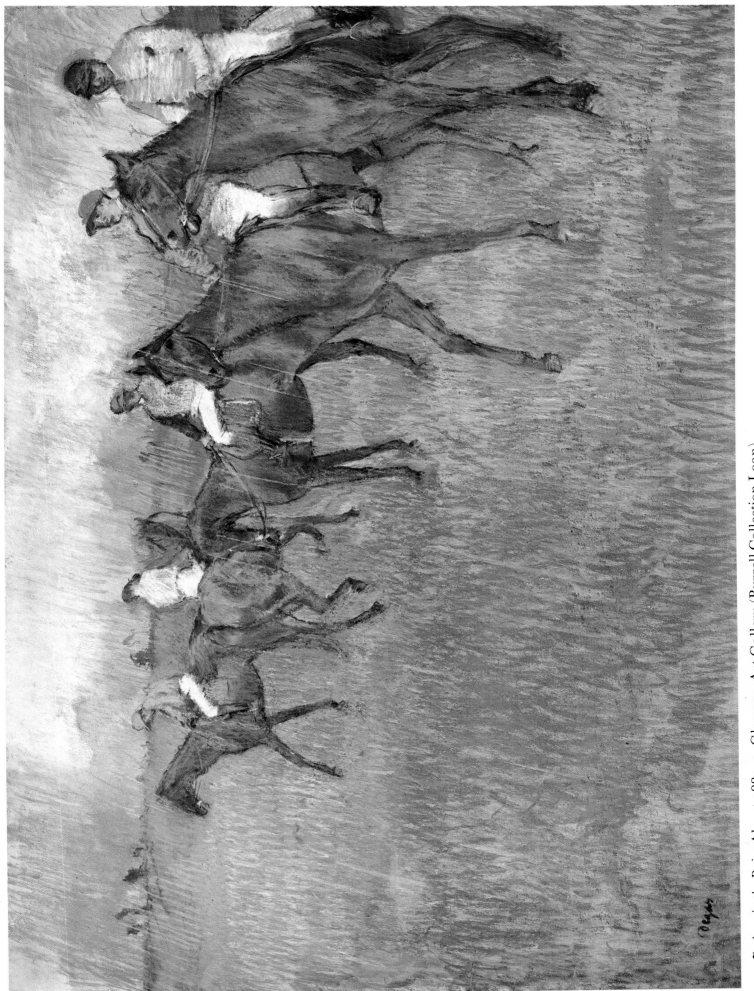

23. *Jockeys in the Rain*. About 1880–1. Glasgow, Art Gallery (Burrell Collection Loan)

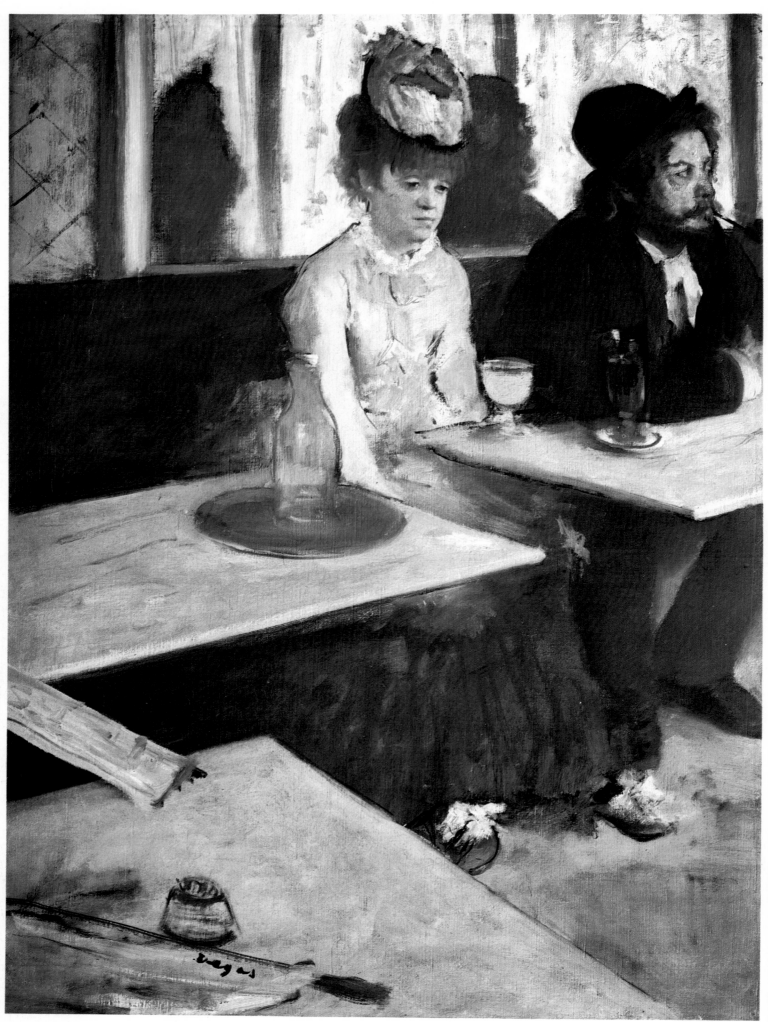

24. *'L'Absinthe.'* 1876. Paris, Louvre (Jeu de Paume)

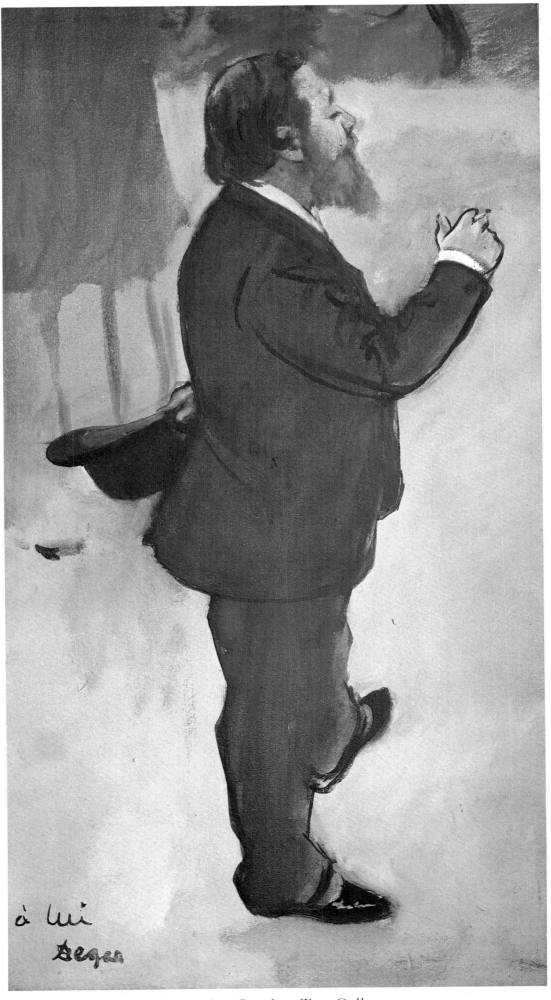

25. *Carlo Pellegrini*. About 1876–7. London, Tate Gallery

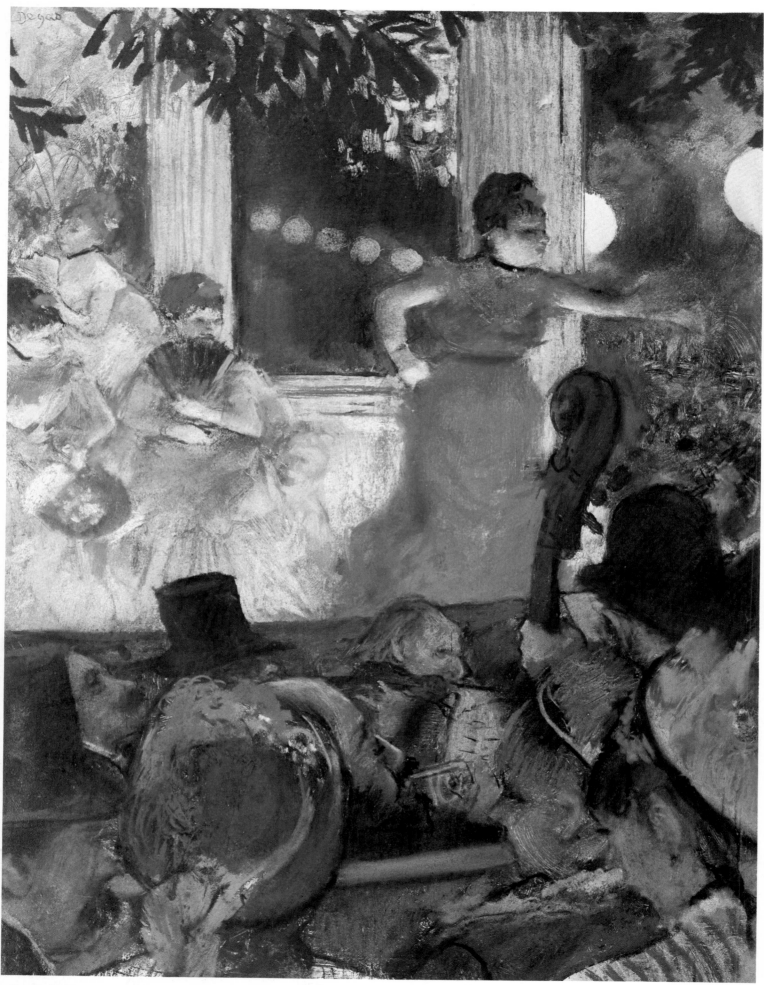

26. *Café-Concert at the 'Ambassadeurs'*. About 1876–7. Lyons, Musée des Beaux-Arts

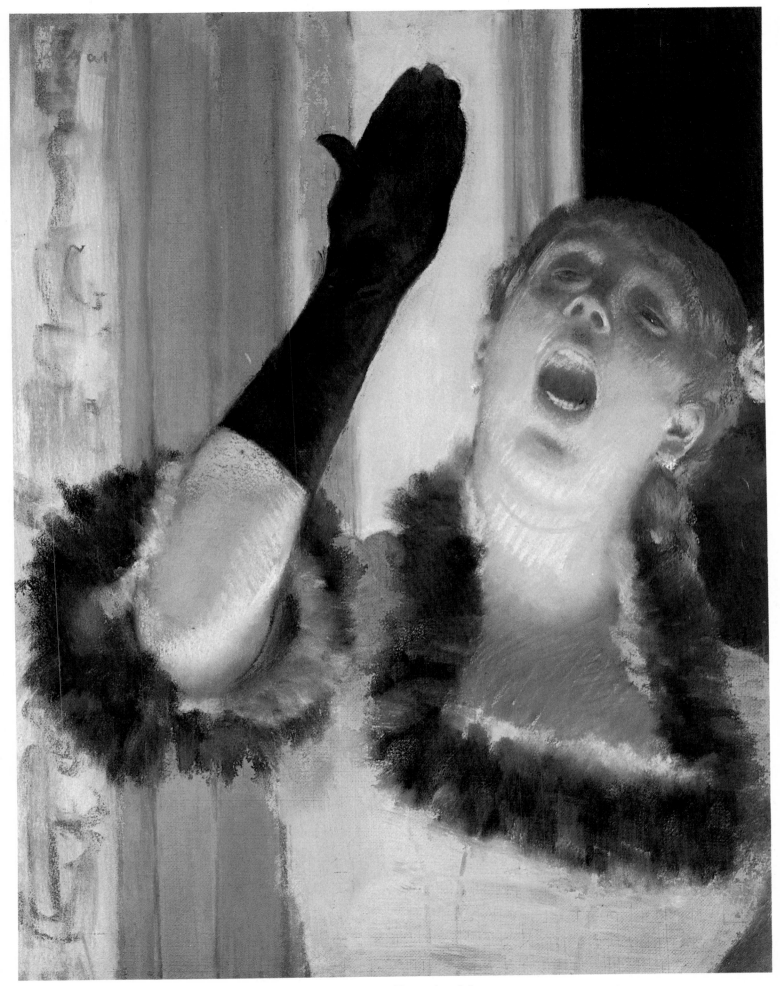

27. *Café Singer*. About 1878. Cambridge, Massachusetts, Fogg Art Museum

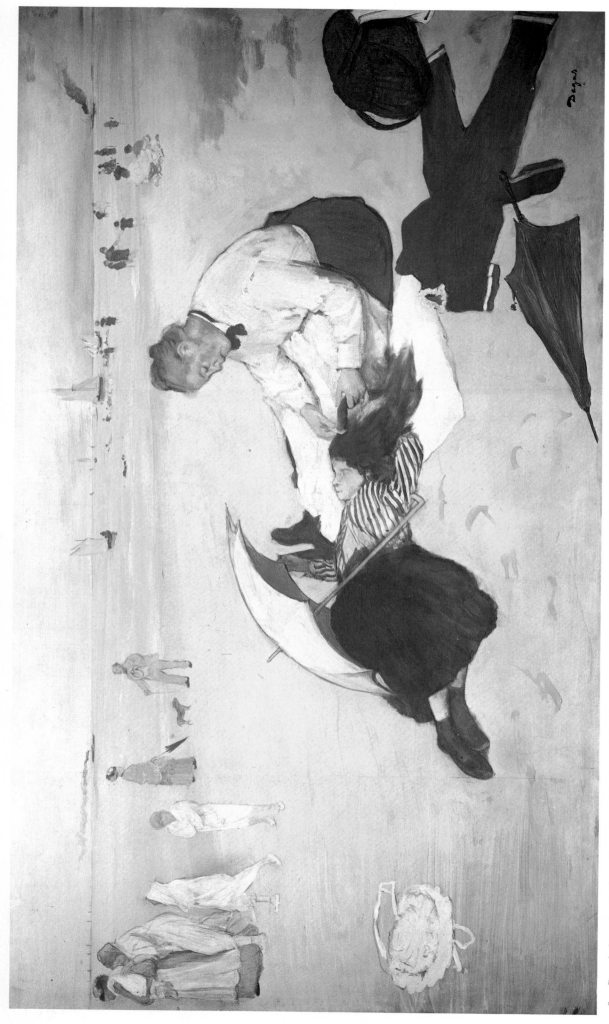

28. *Beach Scene.* 1876–7. London, National Gallery

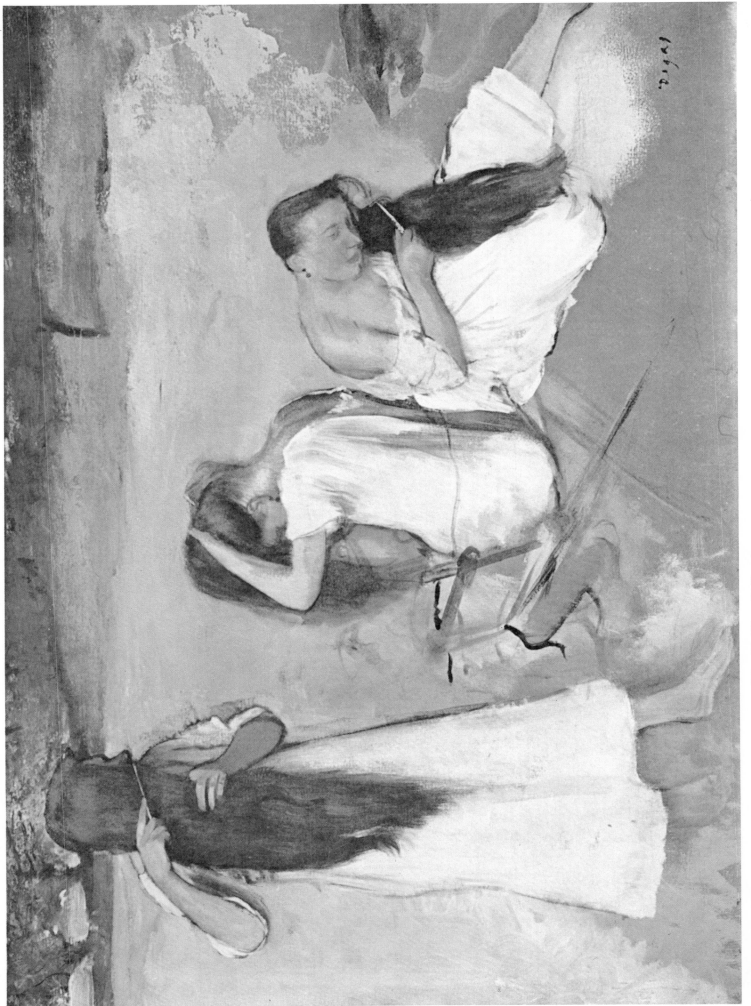

29. *Girls Combing their Hair*. 1875–6. Washington, The Phillips Collection

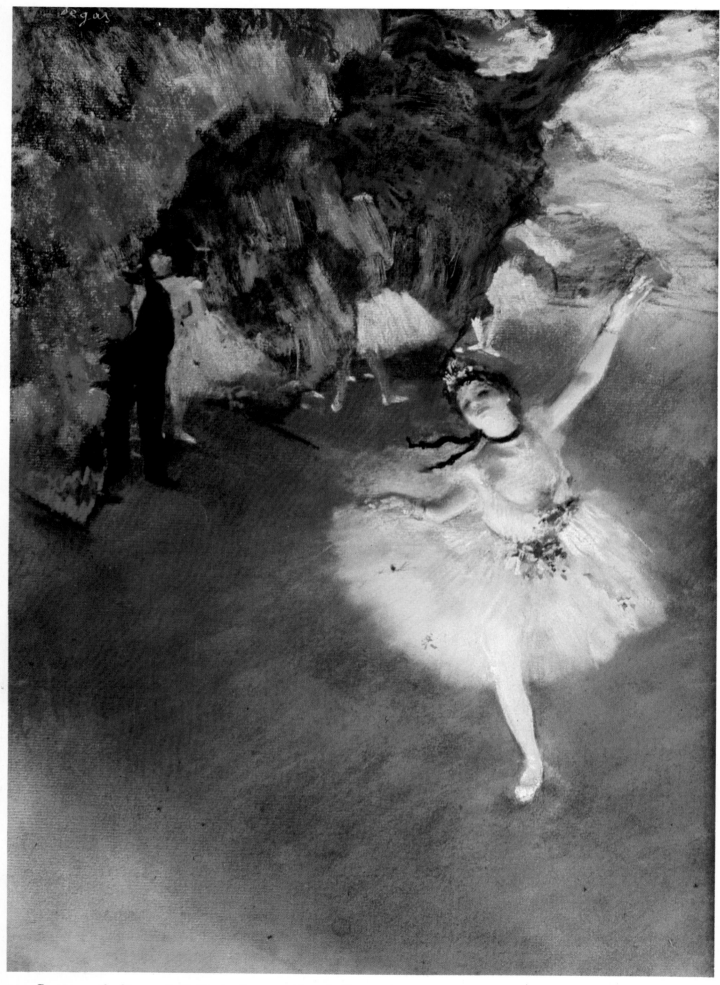

30. *Dancer on the Stage.* 1878. Paris, Louvre (Jeu de Paume)

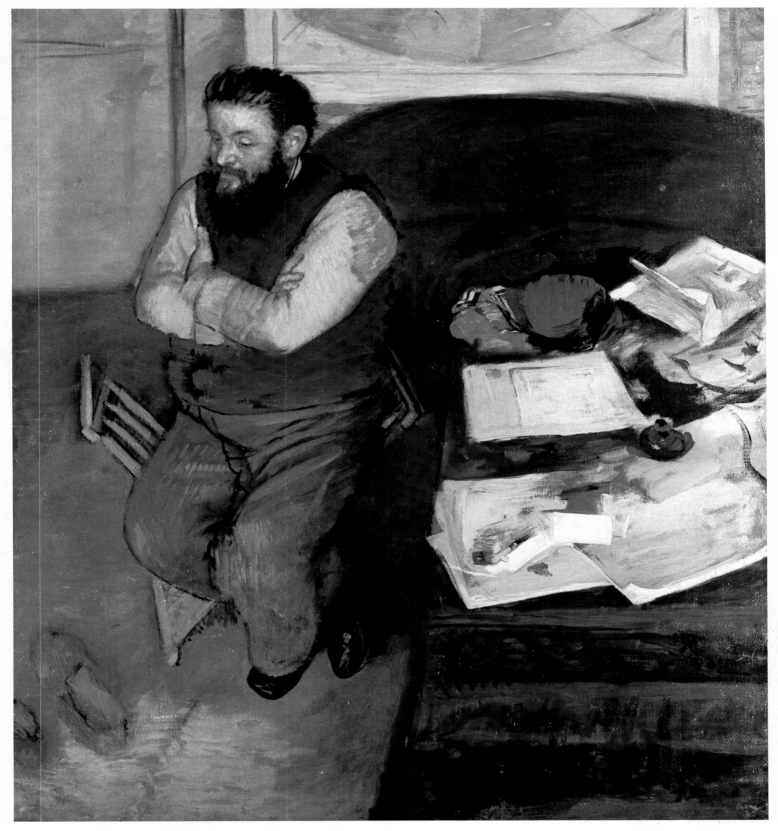

35. *Diego Martelli*. 1879. Edinburgh, National Gallery of Scotland

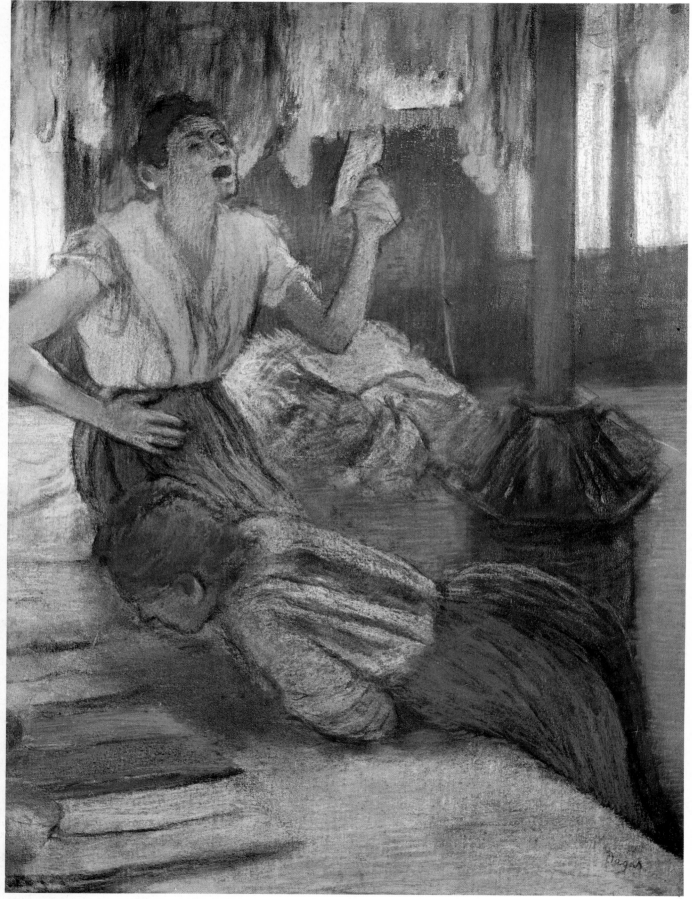

36. *Scene in a Laundry.* About 1884. Glasgow, Art Gallery (Burrell Collection Loan)

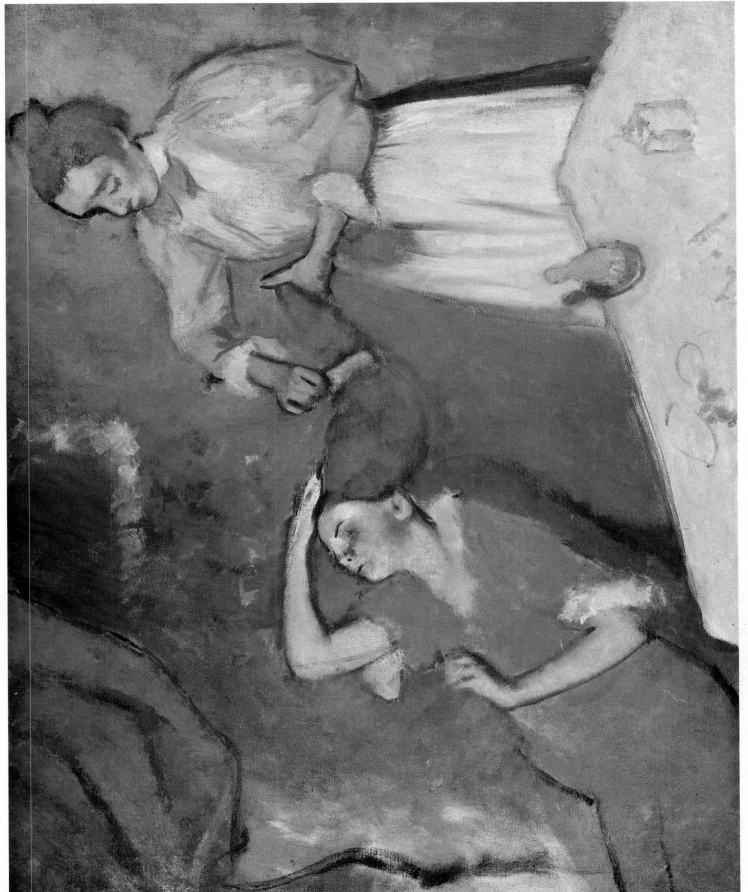

45. *Combing the Hair*. About 1890. London, National Gallery

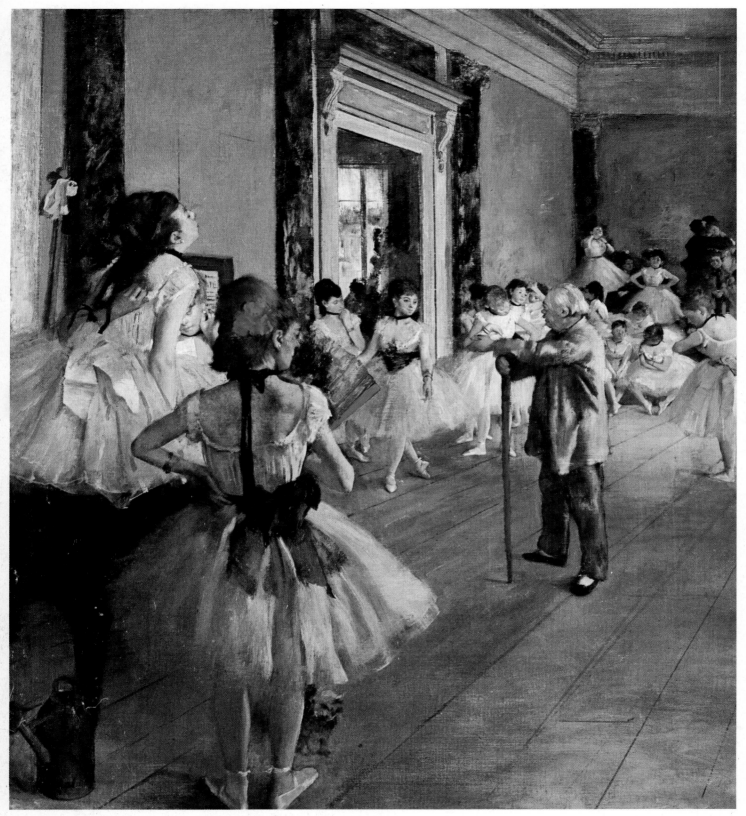

46. *The Dancing Class.* 1874. Paris, Louvre (Jeu de Paume)

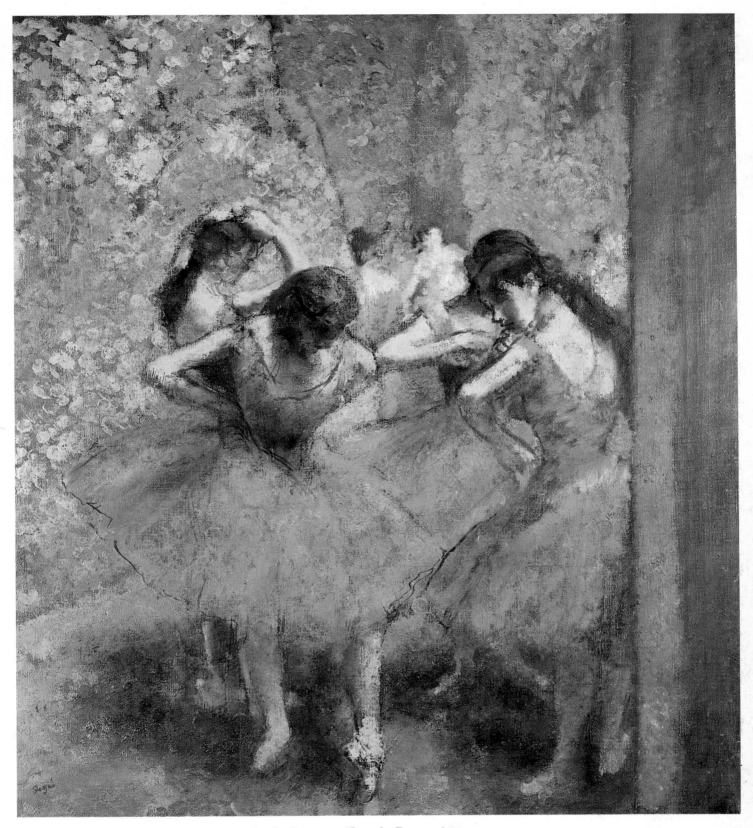

47. *Dancers in Blue*. About 1890–5. Paris, Louvre (Jeu de Paume)

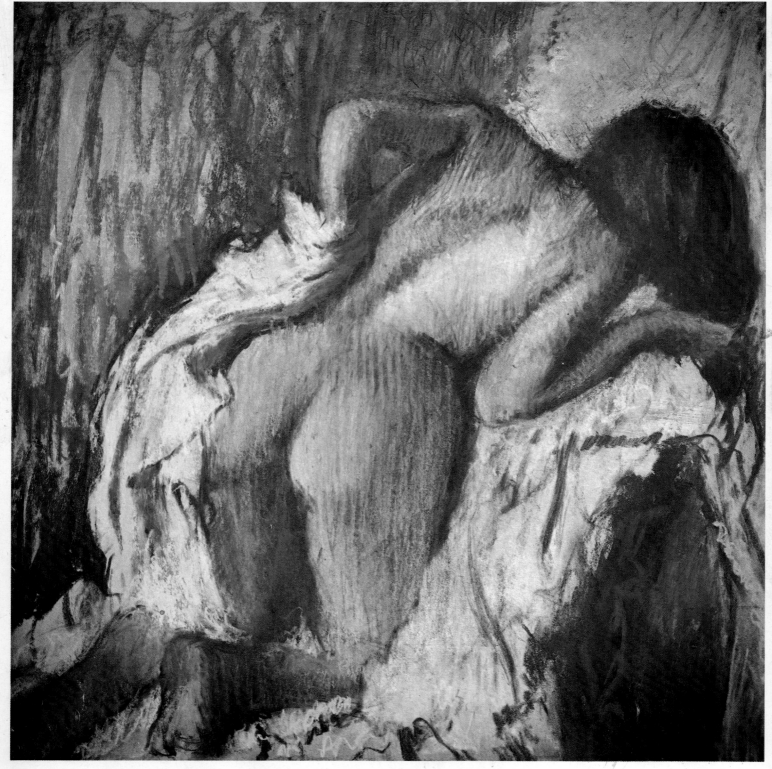

48. *Woman Drying Herself*. About 1890–5. Edinburgh, National Gallery of Scotland (Maitland Gift)